ANGKOR WAT

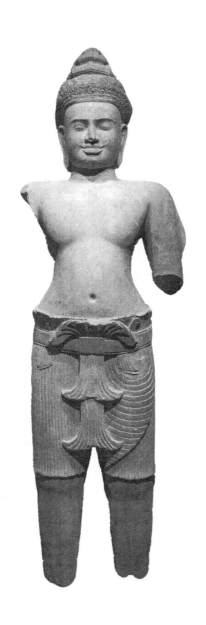

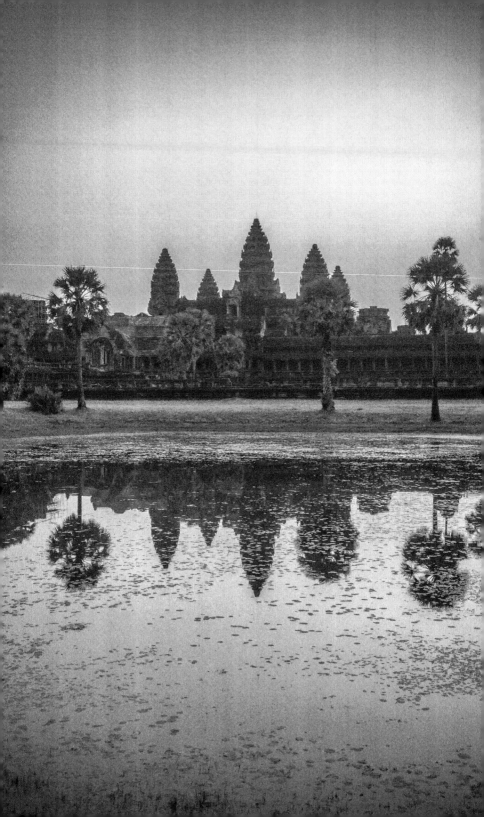

luke kurtis

ANGKOR WAT

poetry and photography

bd-studios.com

Special thanks to Chay Chon, who showed me ancient temples
and helped me fall in love with their wonders,
and to the Venerable Tho Sokhun, my fellow poet,
who taught me about Cambodian culture and Khmer words.

Angkor Wat: poetry and photography

Also available as a spoken word album performed by the author

a luke kurtis/bd-studios.com production
Published by bd-studios.com in New York City, 2017
Copyright © 2017 by luke kurtis

Copy Edited by Karen Lea Siegel
Design by luke kurtis

ISBN 978-0-9890266-8-0

ii

ㅂ

iii

ꟽ

introduction

Angkor Wat tells two stories: the story of my pilgrimages to Cambodia and the story of the spiritual journey of my soul. These poems are very subjective, depicting the intensely personal experience of what it is like to move through these grand architectural spaces and explore the celestial visions they offer up contrasted with scenes of contemporary life in Siem Reap. There is, in fact, a third story here as well, which is your story as you immerse yourself in the words and images.

This book also serves as a tribute to Allen Ginsberg's 1968 book of the same name. Though Ginsberg has long been one of my poet muses, I had never heard

of his *Angkor Wat* book until after my first travels in Cambodia. The book was published only in the UK and long out of print. But as soon as I learned of it, I tracked down a copy immediately. Inspired by what he had done I realized I should continue the work I began with "electric wire," a poem written in Siem Reap during my first visit there. Soon followed the series of poems that make up most of the first section of this book. Later came the realization that there was more work to be done, more traveling to do, and more poems to write. And so that is what I did, returning to the far east to complete what I began on my first journey.

Here, then, is my full suite of poems inspired by Angkor Wat and beyond. I invite you to see Cambodia through my eyes, to take a deeper look not only at the text and the images but, perhaps most importantly, within yourself. Temples are a metaphor of both the cosmos as well as the soul. What will you find inside?

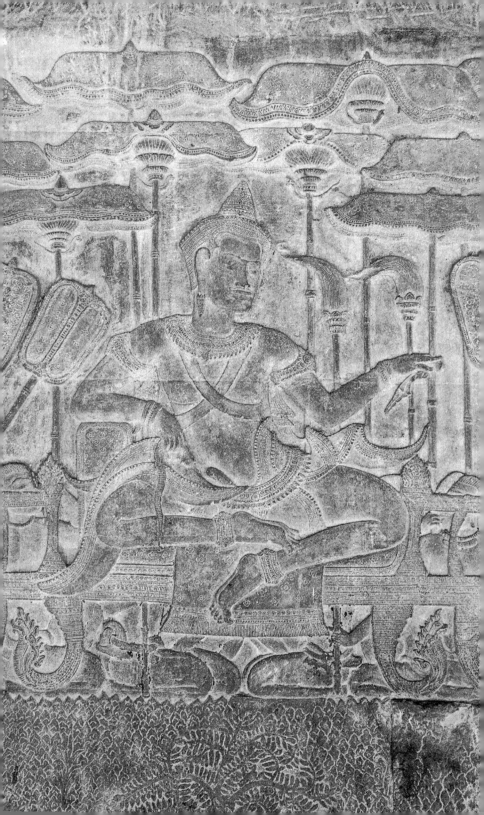

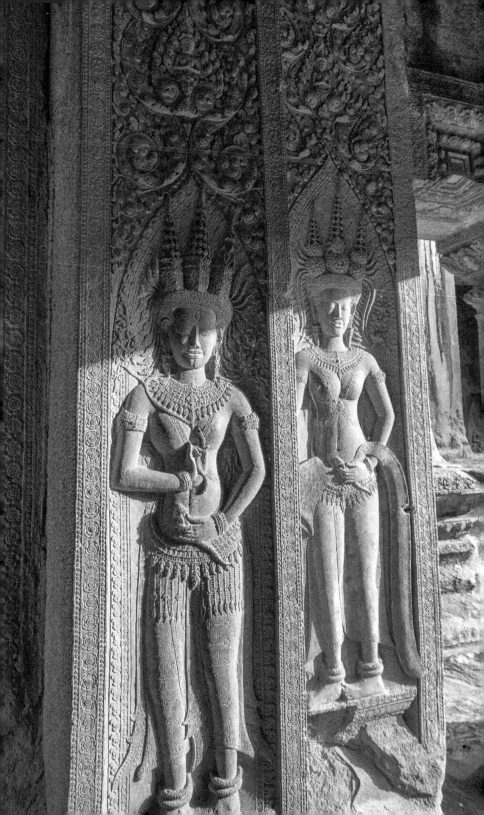

i
9

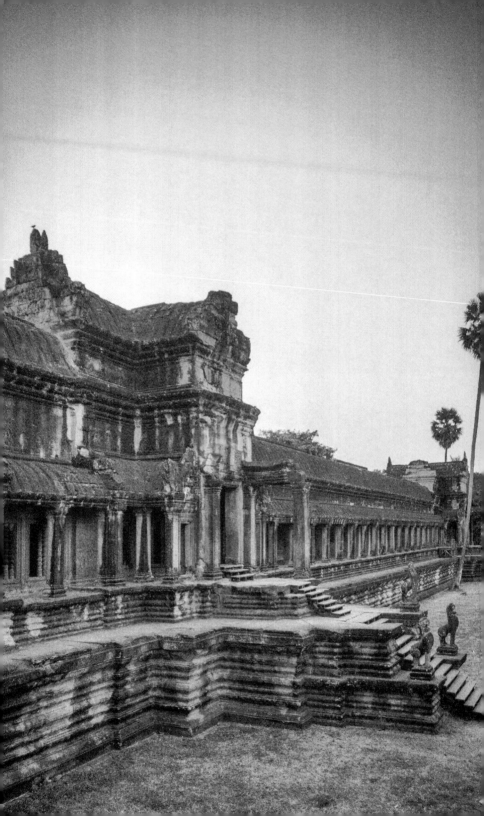

new day

through dark jungle

daylight miles away

i make way to Angkor Wat

perch upon library stones

wait for dawn

with Venus and Mars

sky full of stars

bright as electric wire

strung from here to heaven

gradual peak of light

and call of birds

a grazing horse

people gathering

—waiting—

for the sun's greeting

i listen to my breathing

—echoes—

rhythms emerge

here is morning

on the verge

of a new day

namaste

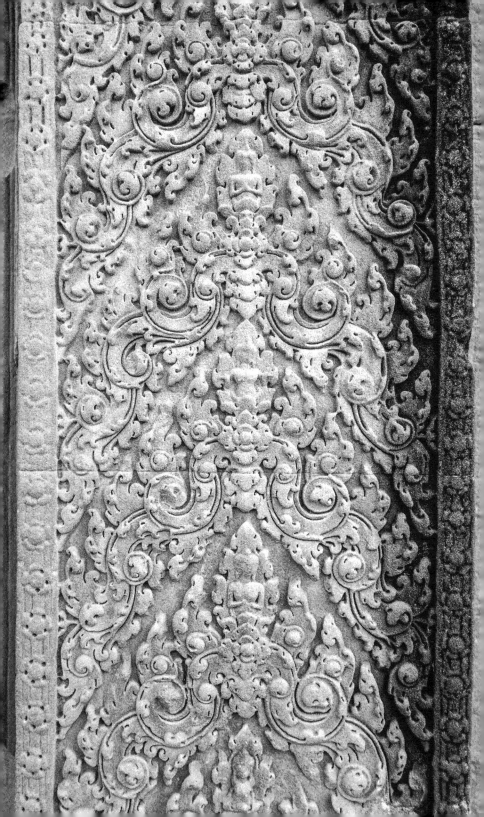

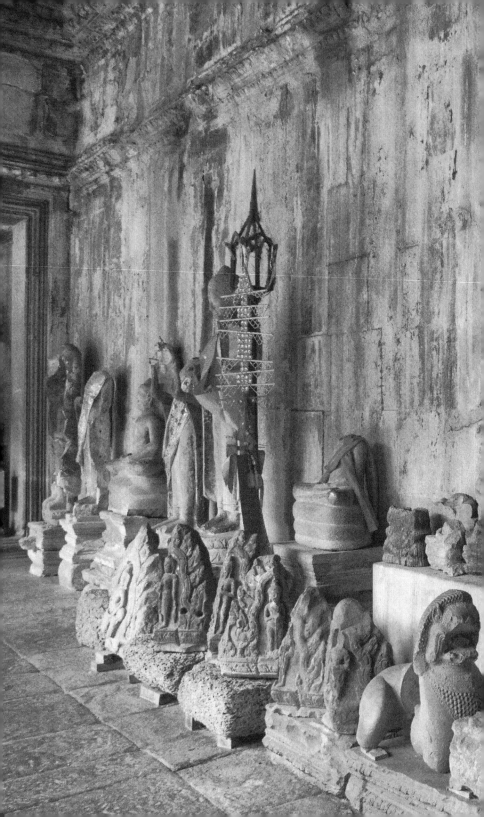

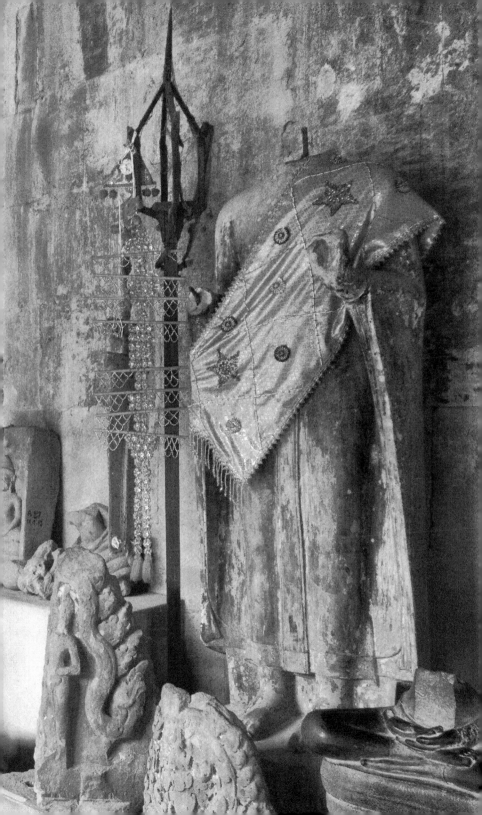

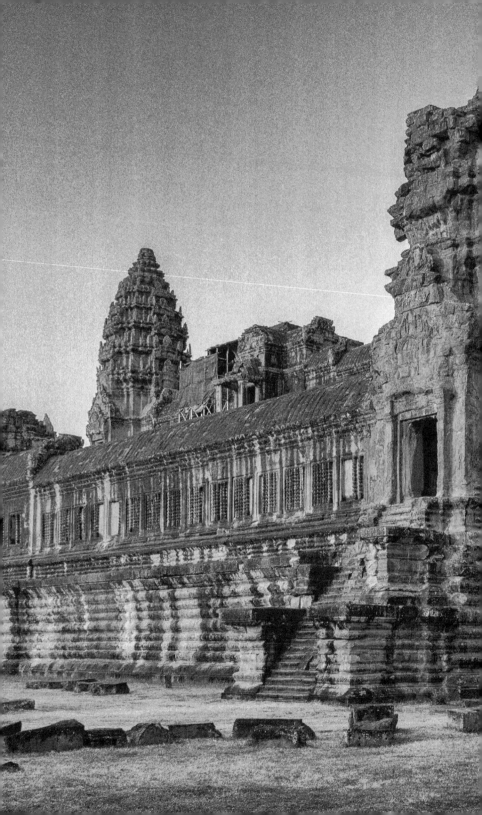

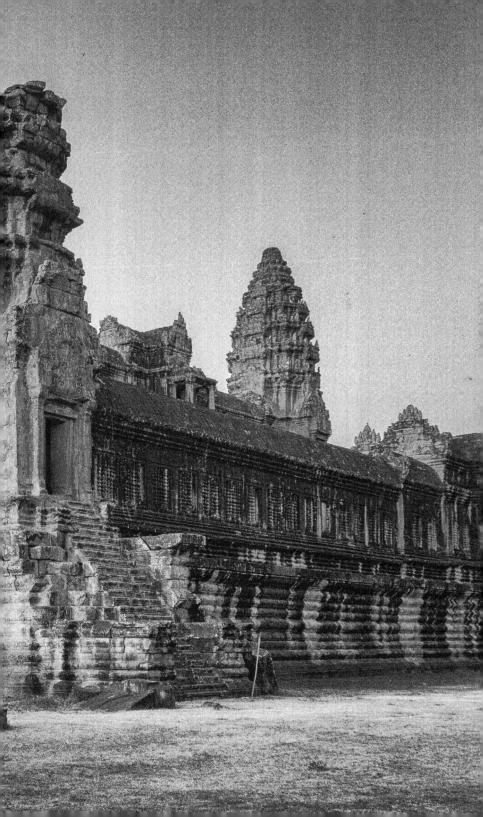

holy mountain

Khmer pyramid, Mount Meru

—Vishnu calling—

golden lotus gleaming skyward

i climb towards heaven

photosynthesis green jungle creeps

in every direction

monks clear dusty ways

under Cambodian heat

and mark this place

holy holy holy

holy holy holy

holy holy holy

to the people of Cambodia

this place holds stories

tales of histories and myths

of devas and asuras

—Mahabharata—Ramayana—

the god king and apsaras

shadows fall upon faces

in quiet beams—traces—of morning light

as solemn sound rises

and sights of celestial love

impart spiritual visions

universal everything oneness

all is sacred; all is art

all is holy; all is part

of everything else

i feel the tender weight of sun

resting on my face

gentle hand of Buddha

hidden among these towers

where lotus petals clasp my wrist

as i chant prayers to—this—

holy mountain

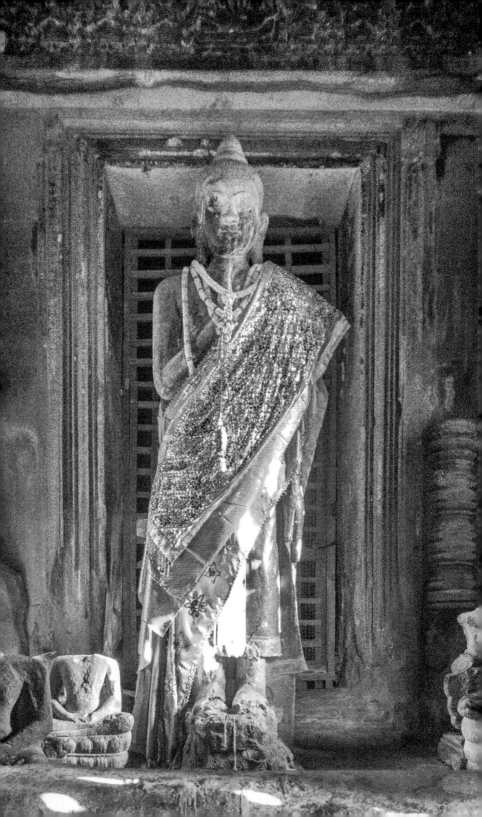

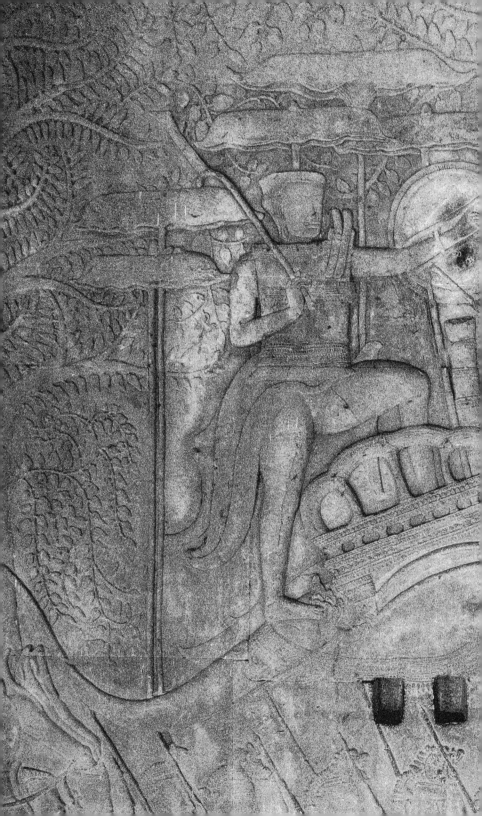

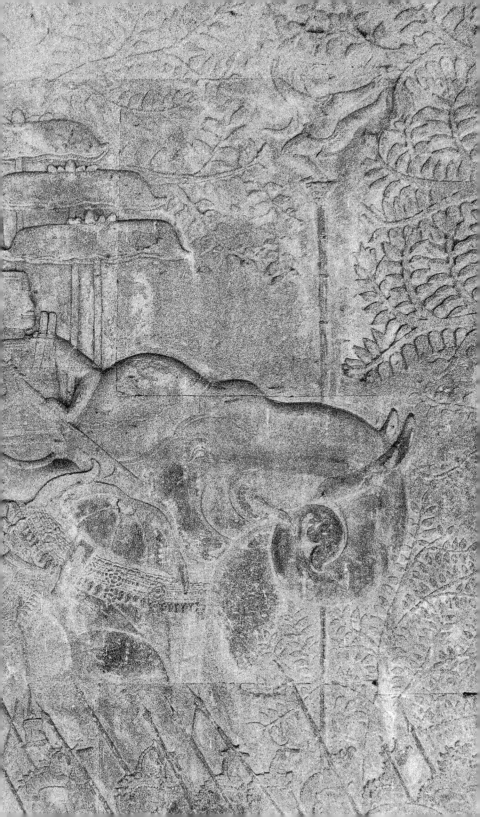

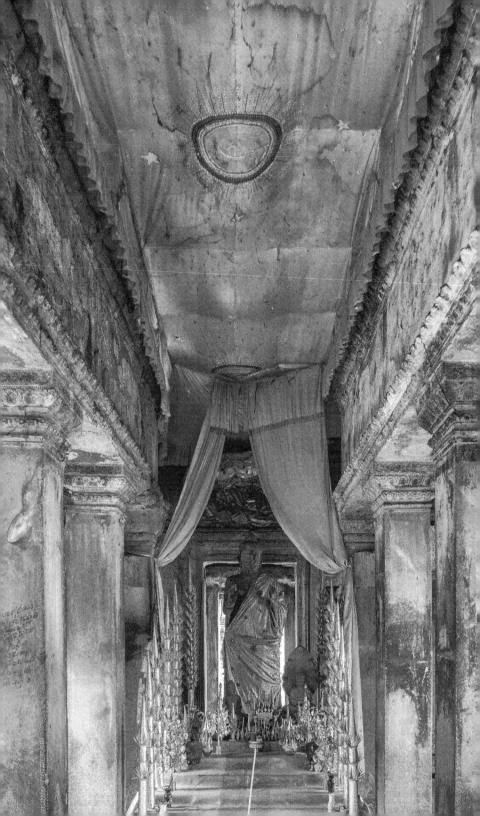

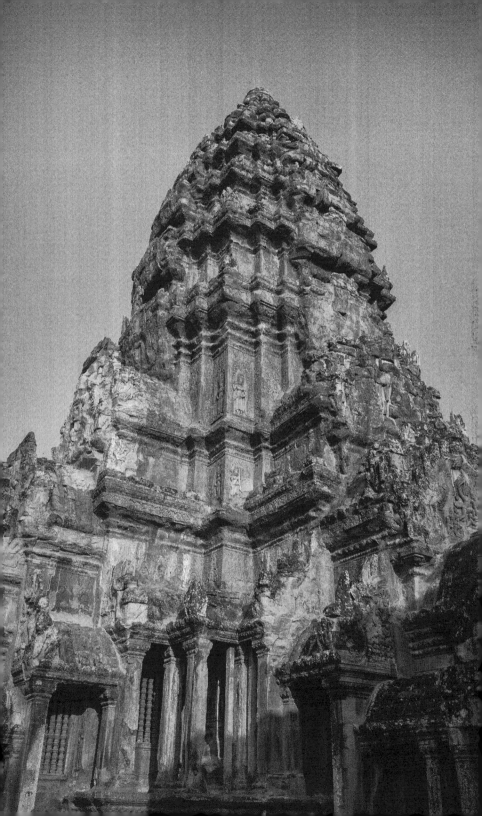

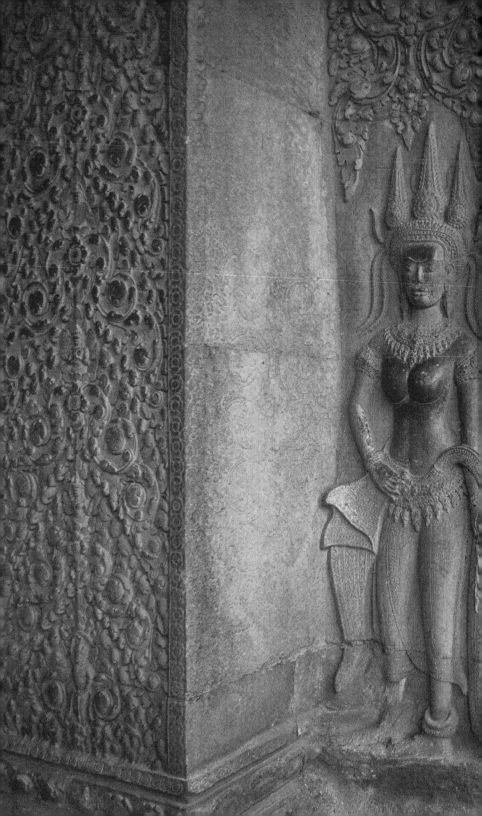

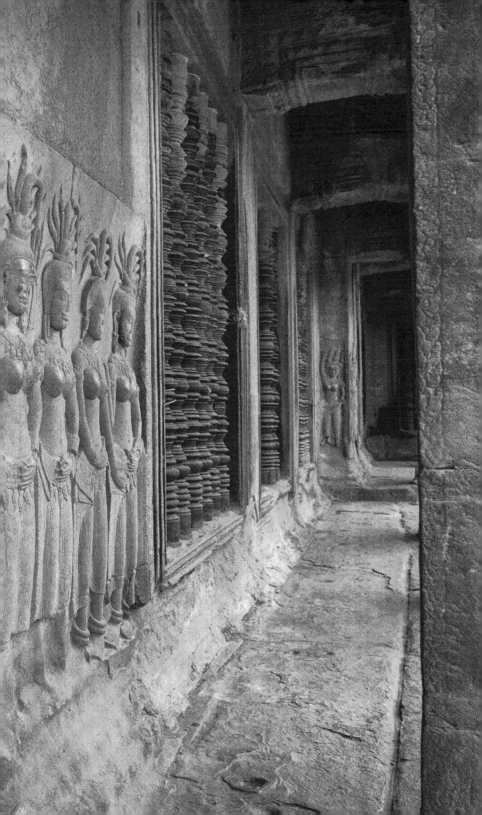

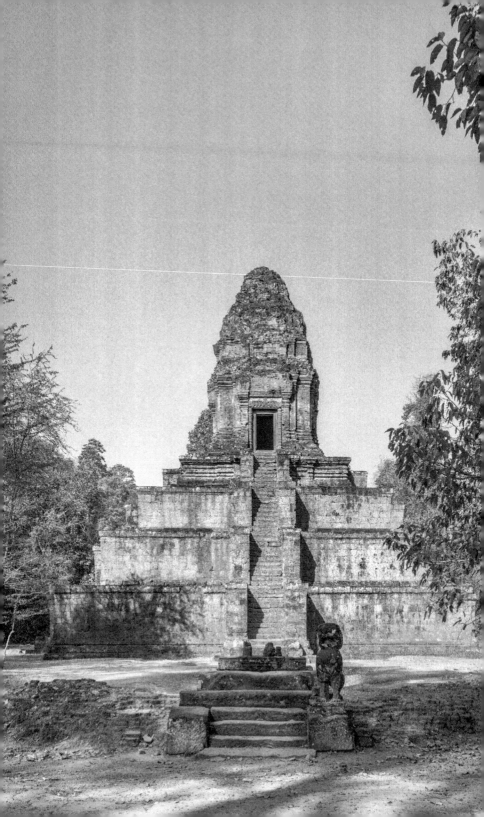

kondol wings

under kondol wings

morning light warms

pyramid steps

intoxicating blossom

effervescent sprouting corporeal

cupped in my hand

nests of ant activity

wrap around leaves

and citrus tongue

bleeding trunk red sap

made for dyeing fabric

different shades of rouge

swimming in temple pools

diving devas leaping

from ancient memory—yesterday—

i make my way

leaving dusty roots behind

—spiritual climb—

Airavata—elephant of the clouds—

carry me like great Indra

—lord of Svargaloka—

lift me closer to heaven

beyond this mound of brick and laterite

where air is thick and light

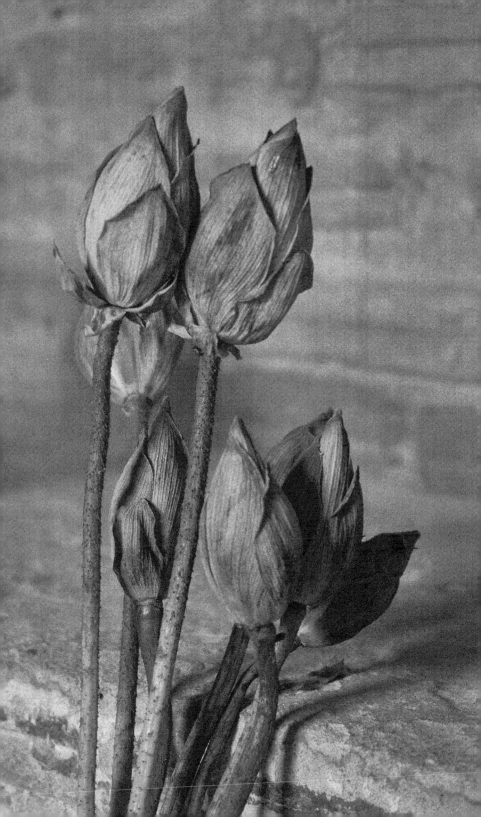

echoes across impenetrable jungle

as i look out from this mountain

this quiet temple

this sheltered fountain

among dried lotus flowers

where Buddha waits out his days

Lokeśvara gaze upon us

and guide us through

the divine procession—together—

to nirvana

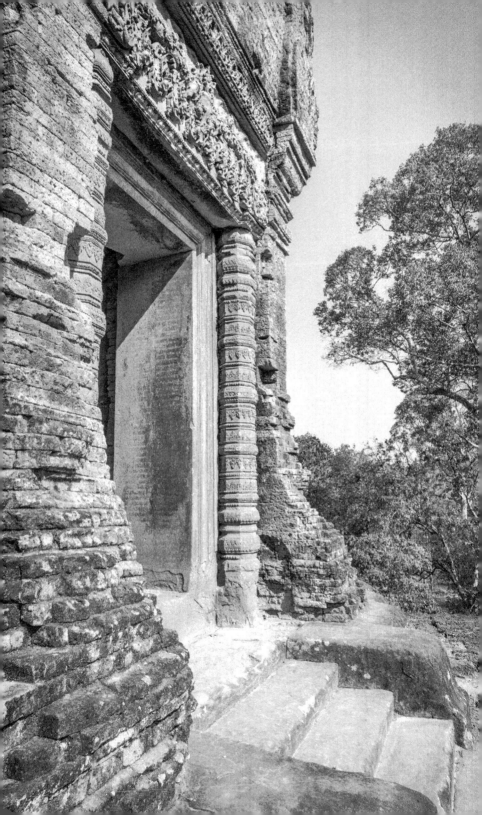

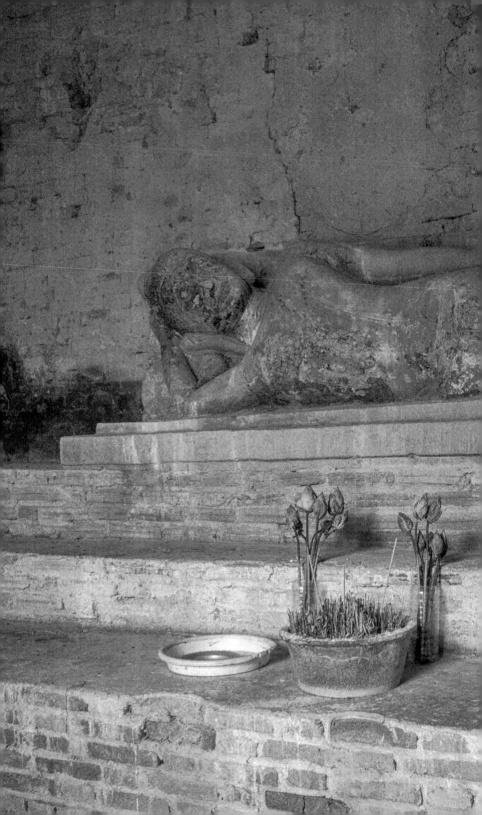

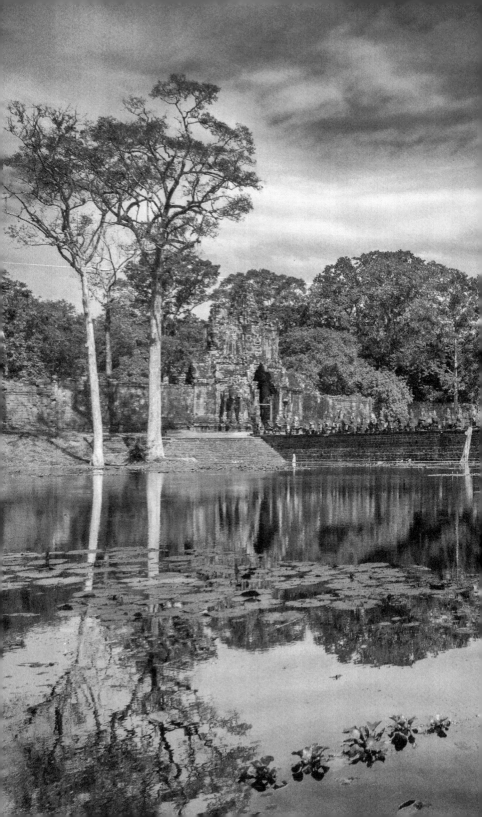

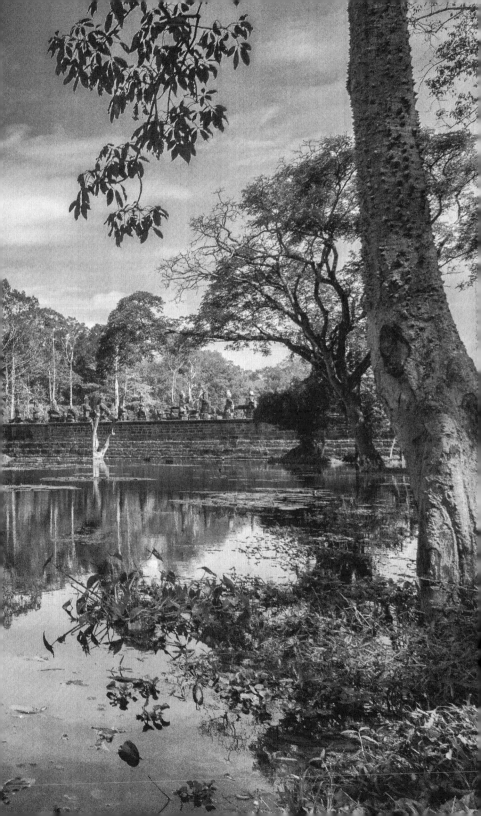

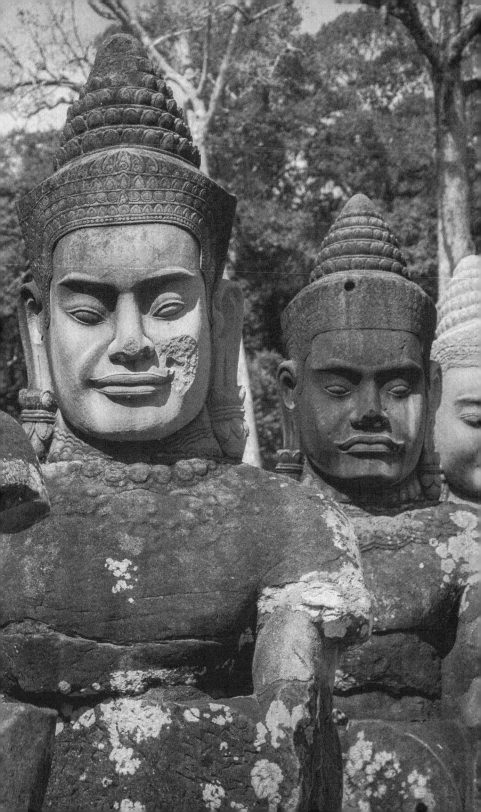

great causeway

along that great causeway

cosmic seas churn

primordial ripples brew

devas and asuras

do the work of creation

across the expanse of nothingness

Jupiter passes by

while rings of Saturn rise

—Uranus, Neptune—soar across sky

Pleiadeans shift position

—mark Mandara—

south to north, east to west

inner planets begin to crest

Mars and Earth follow Mercury

Venus churns with vigor

astral procession of planets

trigger life below the surface

milky white and shimmering

ocean waves swimming

with celestial nymphs

mystic celebration rising

stars are architecture of the sky

where constellations sway above clouds

like elemental towers

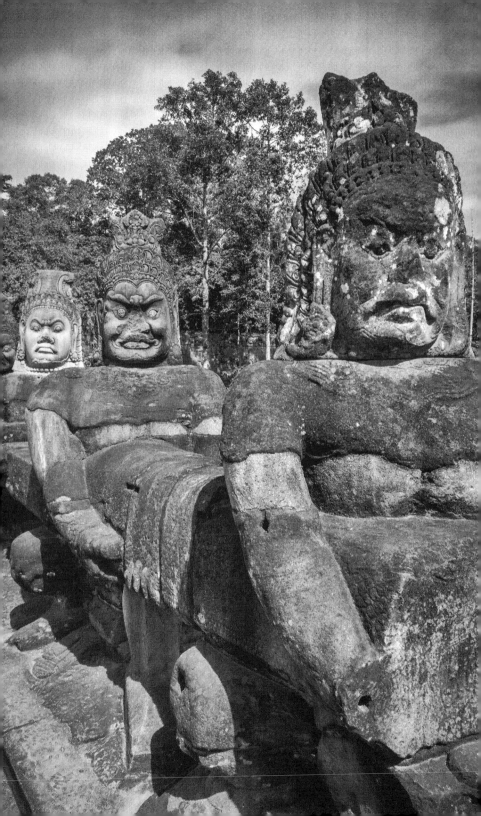

gods heave with great power

wrapped around giant serpent

—tugging, pulling—forth and to

snake skin scales like glitter in the air

through the work of creation where

guardians and demons kick up dust

and Vishnu brews song and elixir

so that buffalo may graze

and elephants parade

along that great causeway

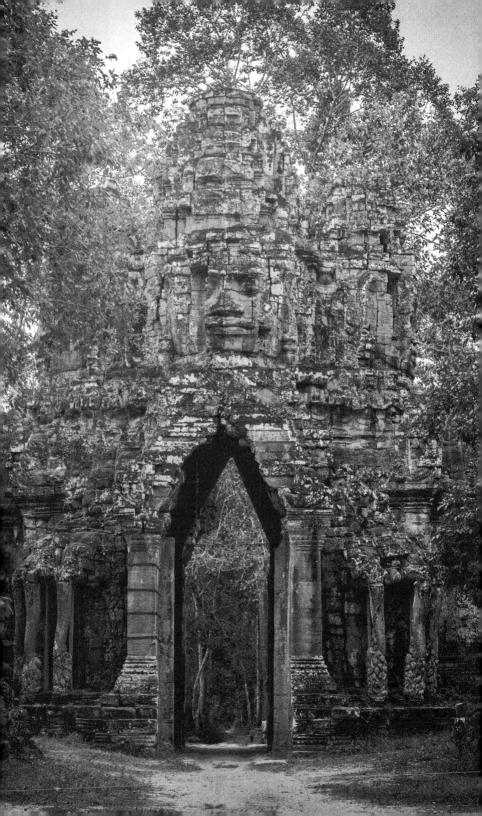

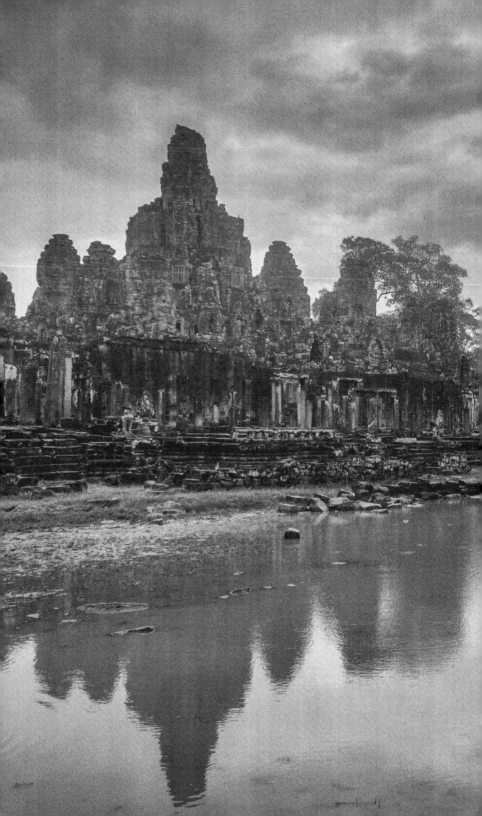

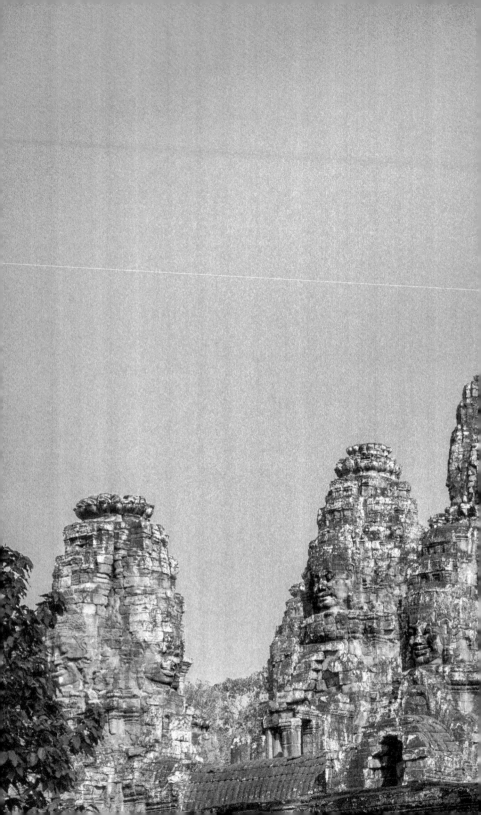

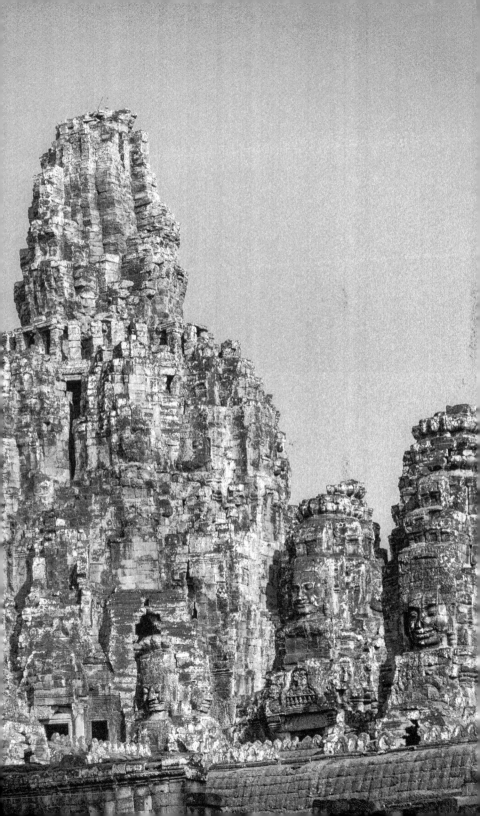

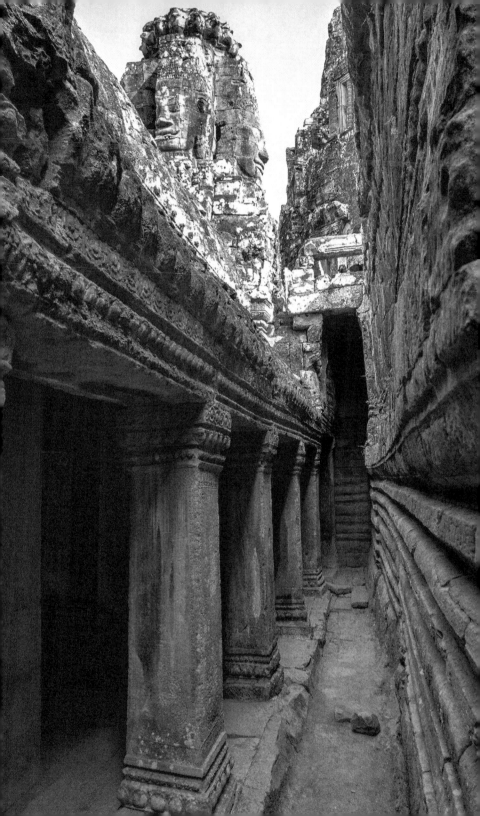

ancient hall

thought occurs over and again

wandering these ancient halls

"this place is part of me"

and i know this is true

feel it in ways beyond words

that i have been here before

the faces of Bayon welcome me

speak in quiet tones

"welcome home"

ruins in decay

breathe sighs of—relief—

memories forgotten

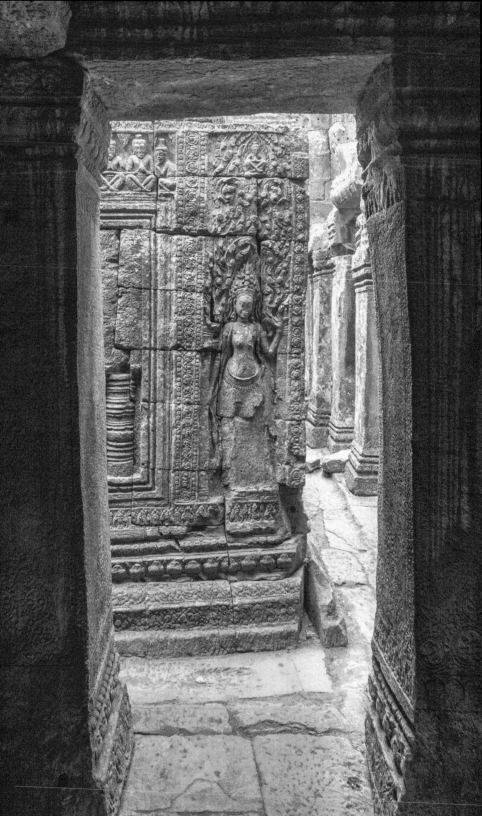

in the hum of buzzing tourists

who wear against stone

rub against feet

the temple of Bayon

—here in Angkor Thom—

ancient city, ancient streets

veins flow through time

shuffling back and forth

Buddhas and kings

forgotten things haunt this place

histories carved in stone

—stories—

i hear apsara

the erotic rhythm

of spiritual dance

and follow corridors

searching for the sound

of this divinity

shadows fall

—a shaft of light—

my pupils adjust

and soon i am thrust

among fervent

Bayon ritual

scent of incense lingers

devatas guide the way

and i take sanctuary

among clouds of music

—percussion, chanting—

apsara dancing

hips sway—undulate—

breasts of mother's milk

medallions of desire

her head—there are many of them—

points to smiling faces

but doesn't everything here point to Buddha?

the faces—all as one—

turn to me grinning

"this is only the beginning"

he whispers and continues:

"everything here—it's not about me,

it's what's in you."

the light shifts, shadows move

music fades into throngs of language

pushing its way through

people pose for photos

—smiling faces in front of faces—

unaware of the magic in these places

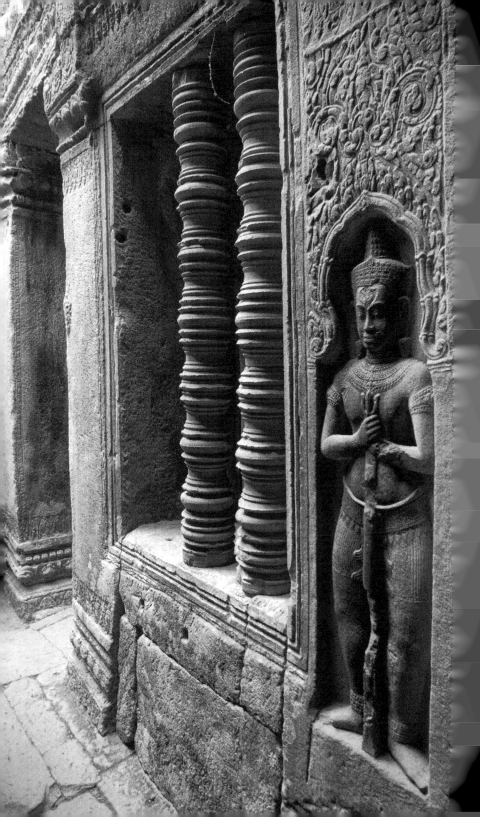

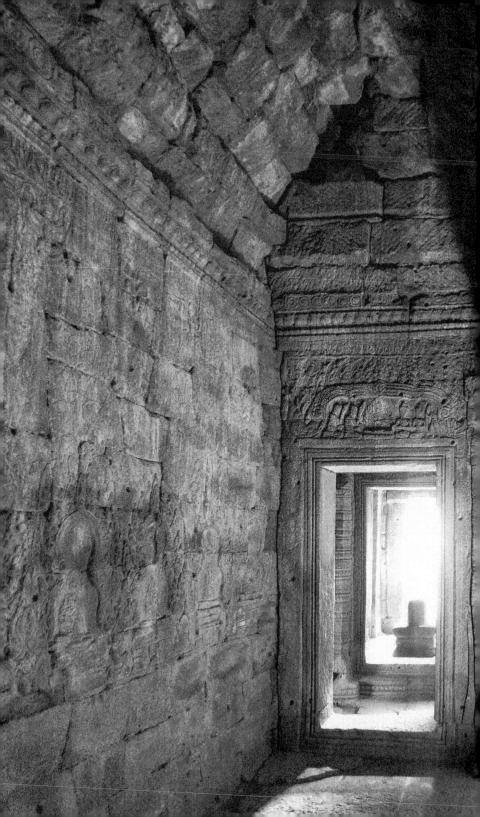

these temples of Angkor Thom

these ancient songs

this ancient hall

thought occurs over and again

"this place is not part of me,

this place—is—me…

yet part of us all."

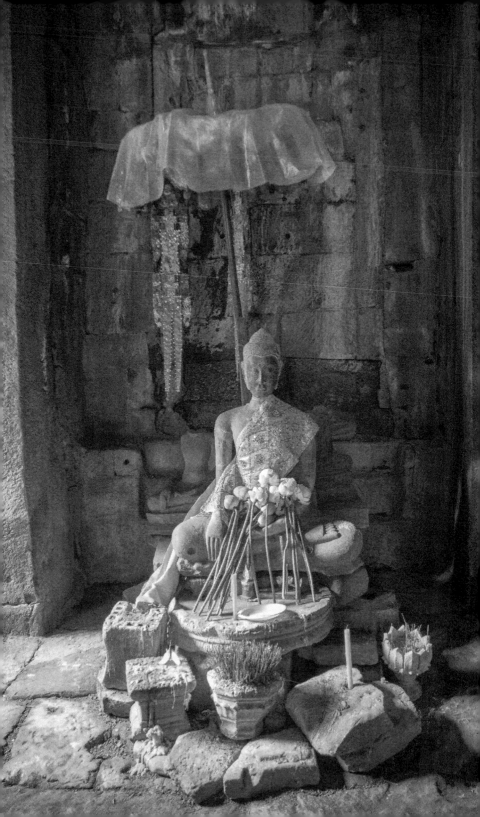

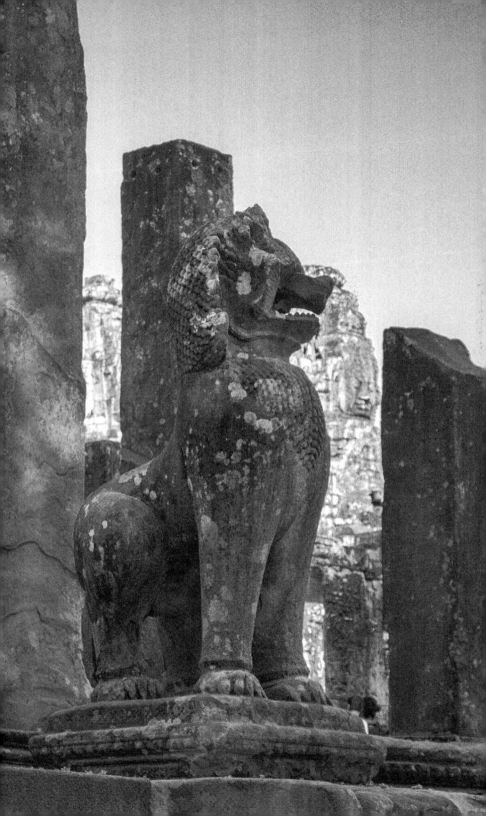

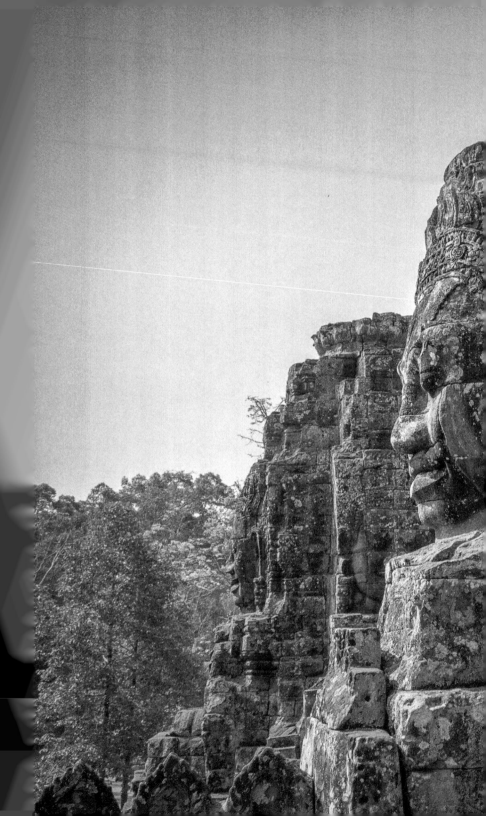

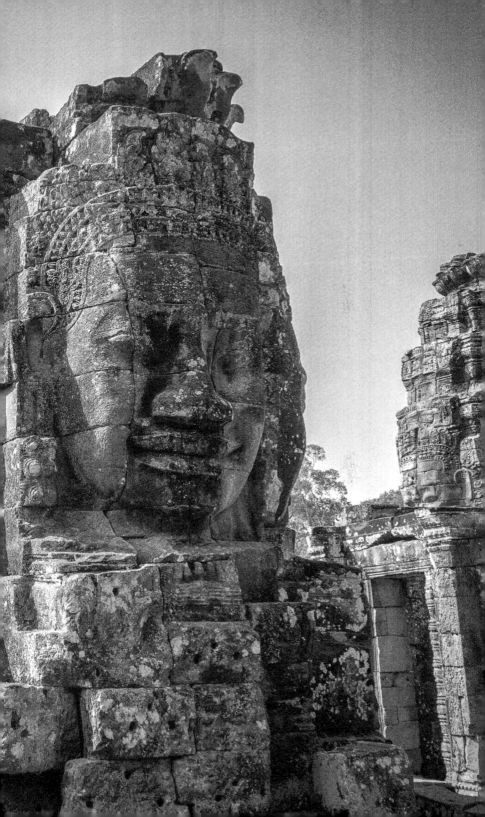

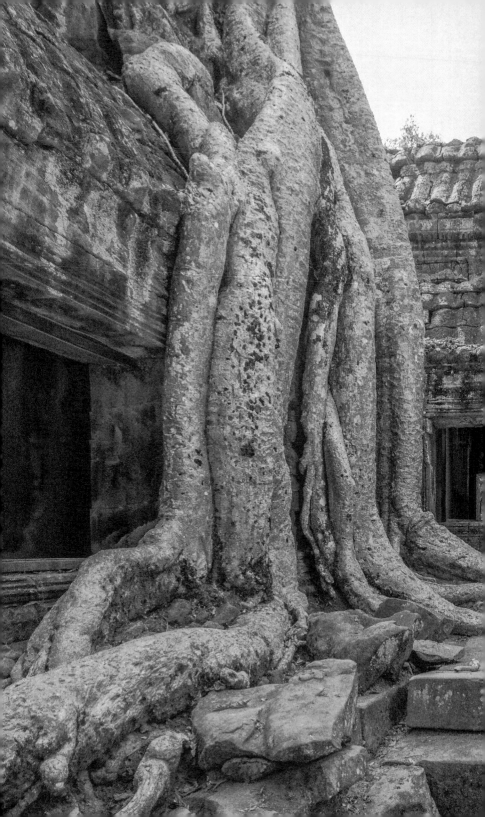

quiet sounds

tetrameles arboretum long

chokes at temple stone

slow tendrils conceal—excavate—

chiseled chambers that men create

and time must tear apart

through monsoon rain

and Cambodian dust at Ta Prohm

Ta Prohm, temple that must

weather nature's temperament

temple that stands against

the steady pull of gravity

and the push of gentle roots

menageries march through corridors

temple spirits, guardians of these halls

and monastery attendants

Prajnaparamita calls us forth

infinity streams out before

—behind, beyond—

we are unborn

our essence is neither here

nor there

Ta Prohm is without duration

—everywhere—

should these walls fall or stand

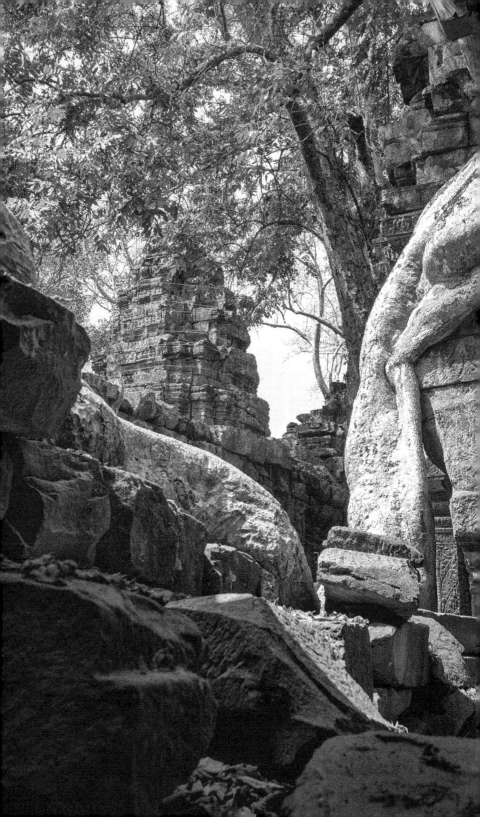

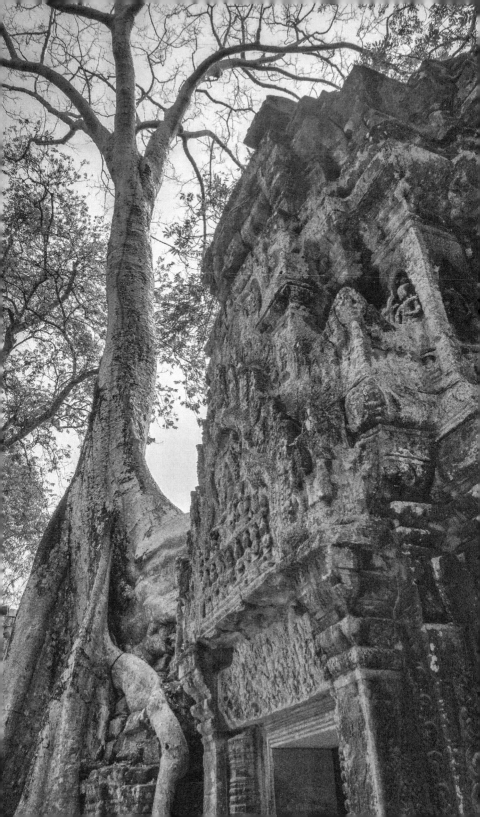

the story—the narration—

remains the same

waiting for still moments

bathed in lush green lilted

echoes of jungle

and quiet sounds of

crawling vine

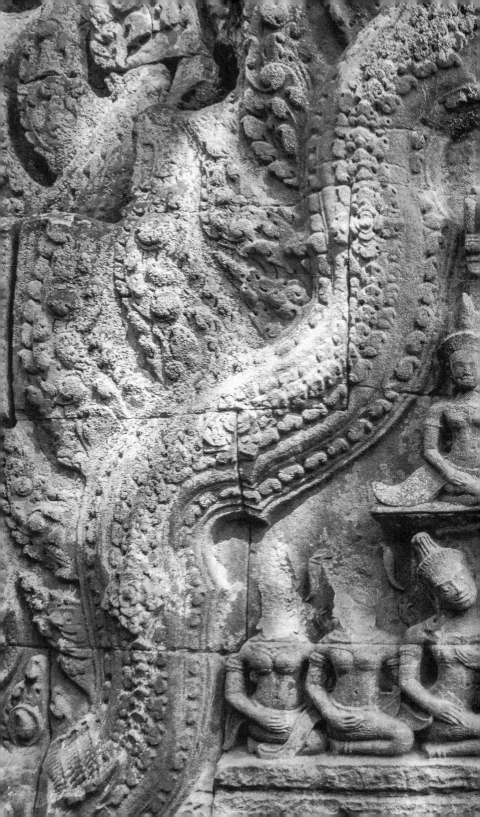

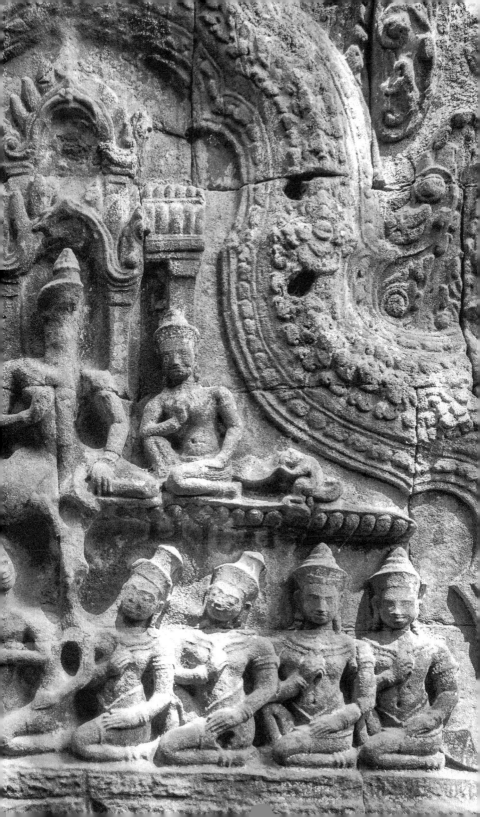

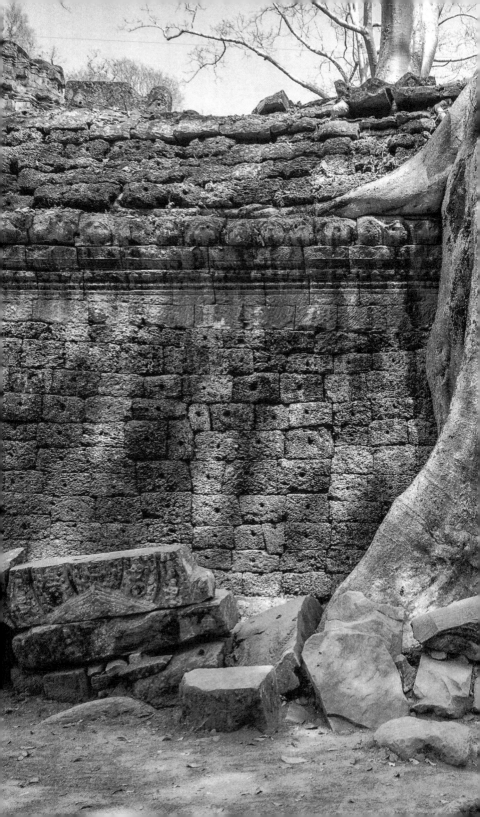

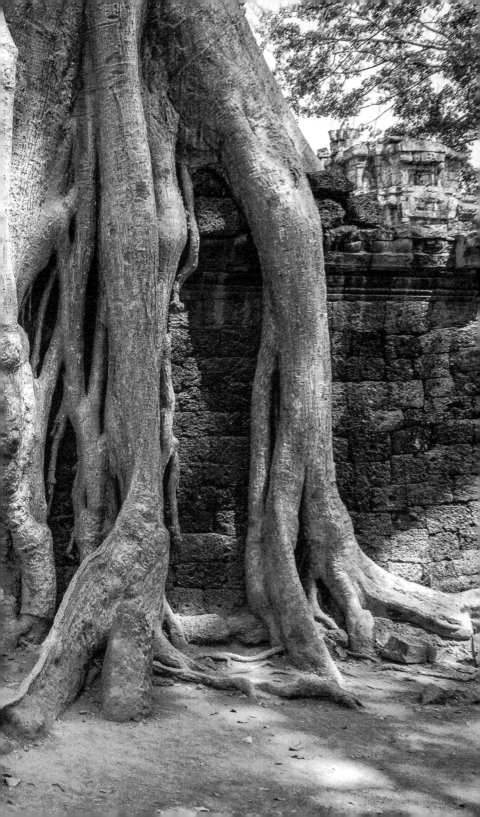

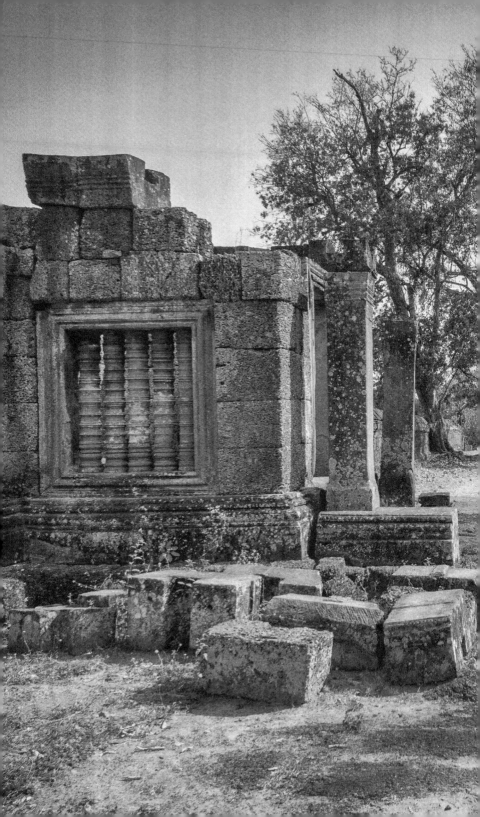

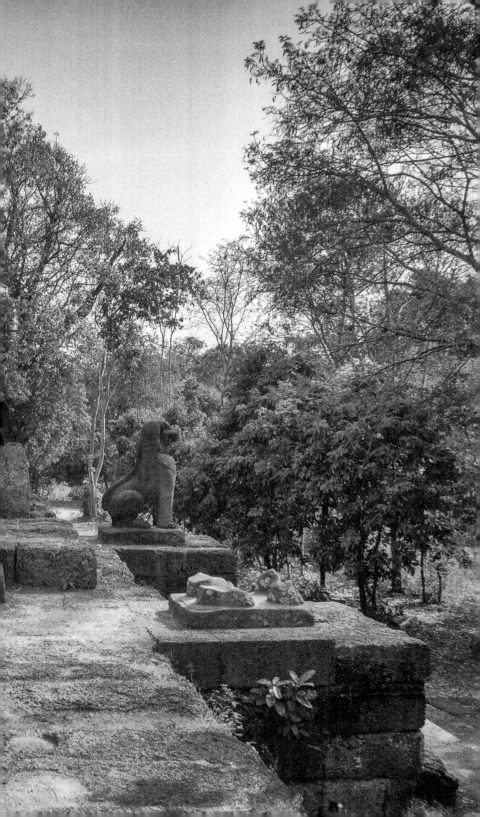

consecrated stone

if i were to build a temple

it would be an island

—lonely, unto itself—

guarded by lions

with elephants greeting

devoted travelers

East Mebon–temple of my heart—

you hold ancient myths

like the depths of my imagination

your quincunx arrangement

a stable procession

marking days, years, decades

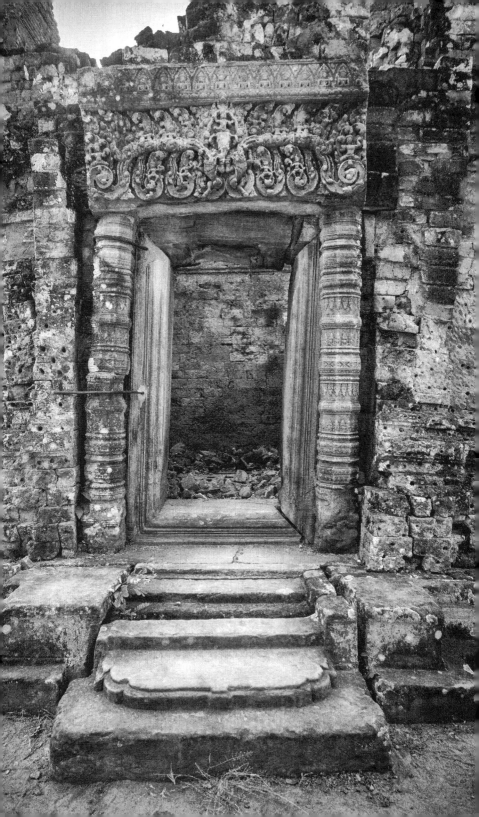

—centuries—

standing under sun

water lapping at your edges

like distant memories

under the delicate press of time

—vison passing—

lotus blossom hatching

open toward sky

a divine egg

a fertile birth

a miracle worth

multitudes of diamond

the sea of creation

—born—

then dying

cracked egg shells

torn lotus petals

strewn in all directions

across thin membranes

between earth and heaven

and the seven chakras

where your consecrated stone

weathers Brahma's vibrations

at Vishnu's command

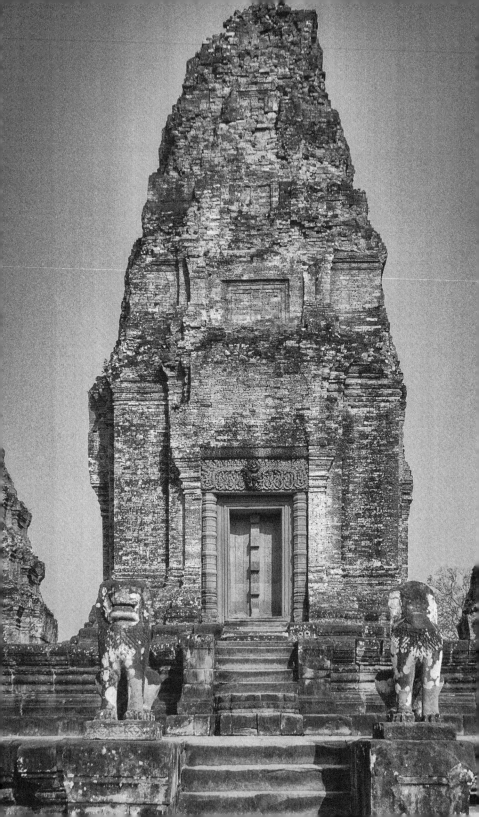

your five towers rise

at Shiva's hand

and even though the sea is dry:

it is not dead

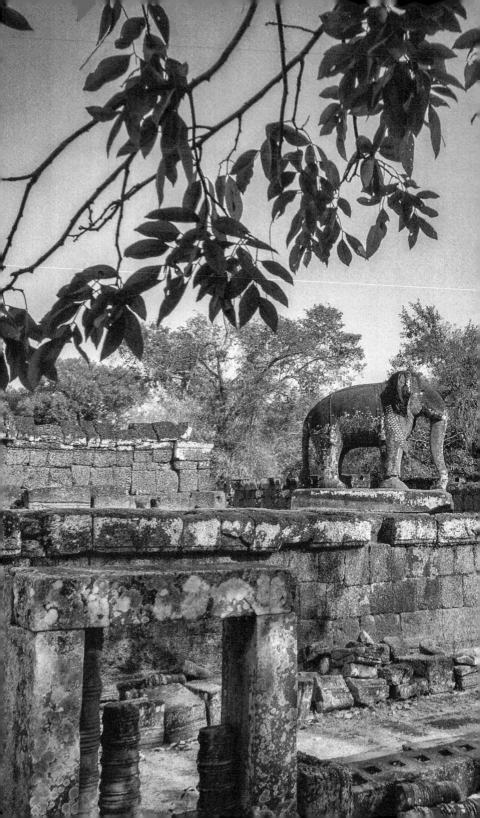

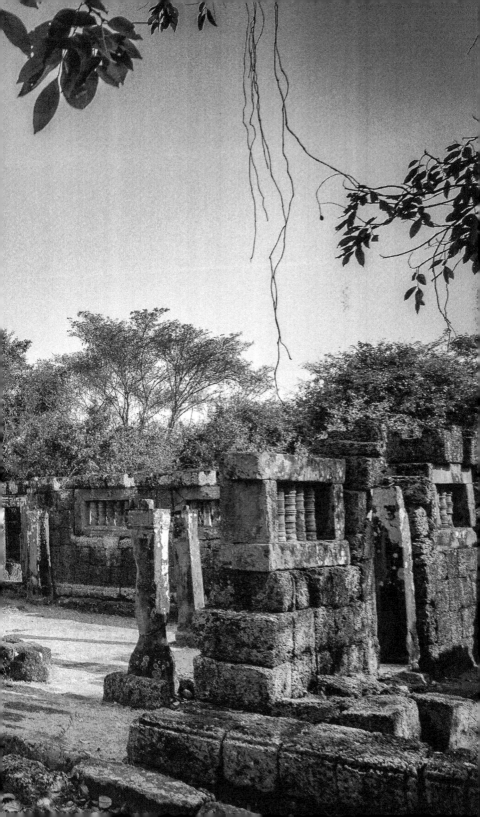

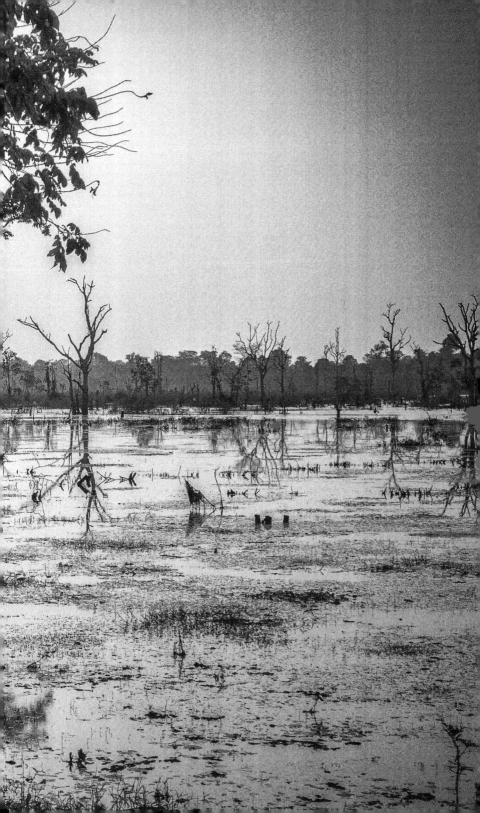

garden pond

there is an island

on an island; a lake

within a lake

called Neak Pean

in the Jayatataka baray

oh if i could bathe in Anavatapta

with the lion, elephant,

horse, and ox

from whom your rivers flow

and before i know it

the water sweeps away

all negativity, all anxiety

—all insecurity—

washing across the backs

of Nanda and Upananda

i hear thunder cry and

heaven opens her eyes

lonesome tears echo across water

the surface reflects a golden light

metallic glimmering shimmer

saying, "this is the way

if you follow in your mind"

i move to the side

and snap a photo

looking towards

the central sanctuary

—the center of earth and time—

then make my way

to a small shrine

dug underground

with incense rising

amid lotus

and sla thour bay sei

this is my time

for silent prayer

a quiet moment

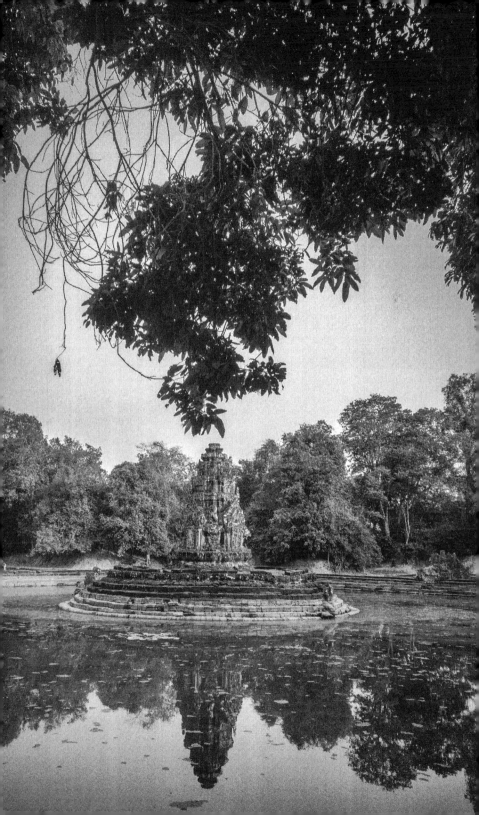

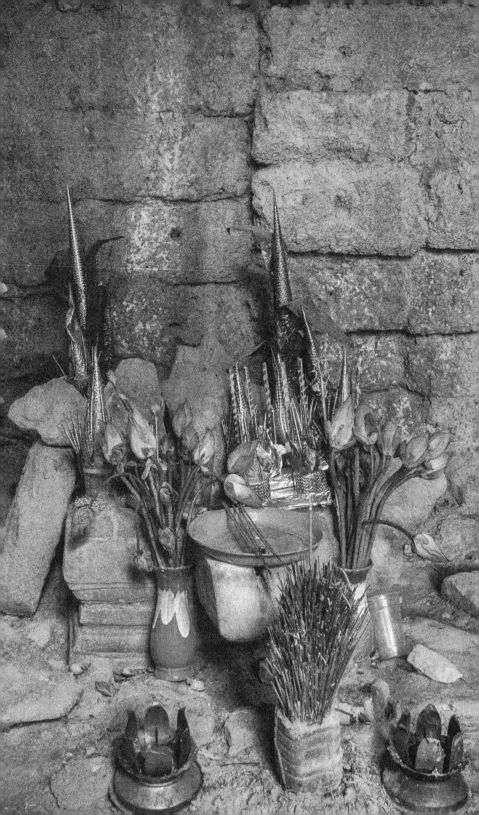

amid Himalayan magic

resurrected—here—in the jungle

our garden pond

without heat

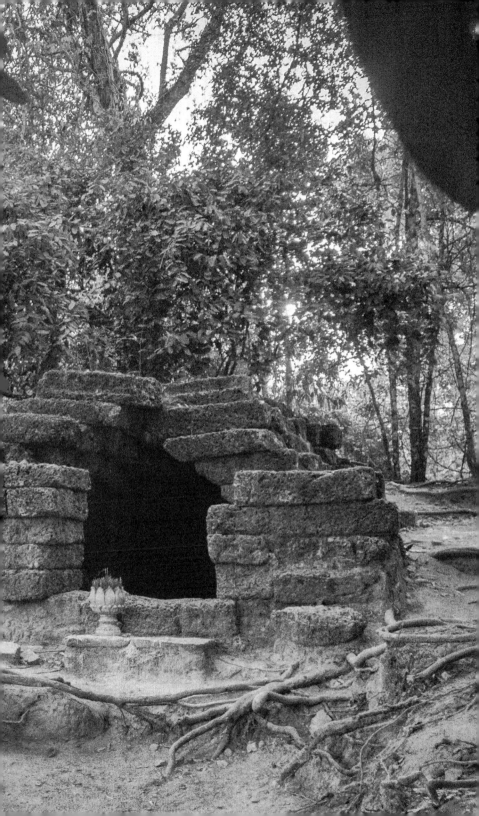

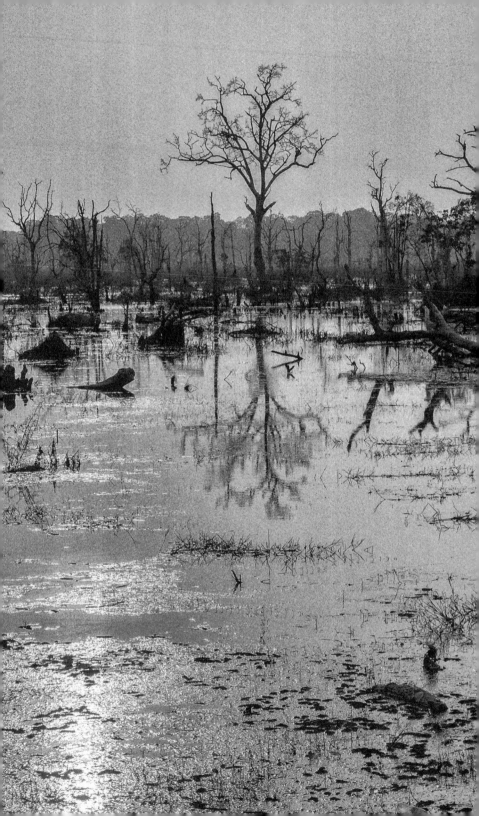

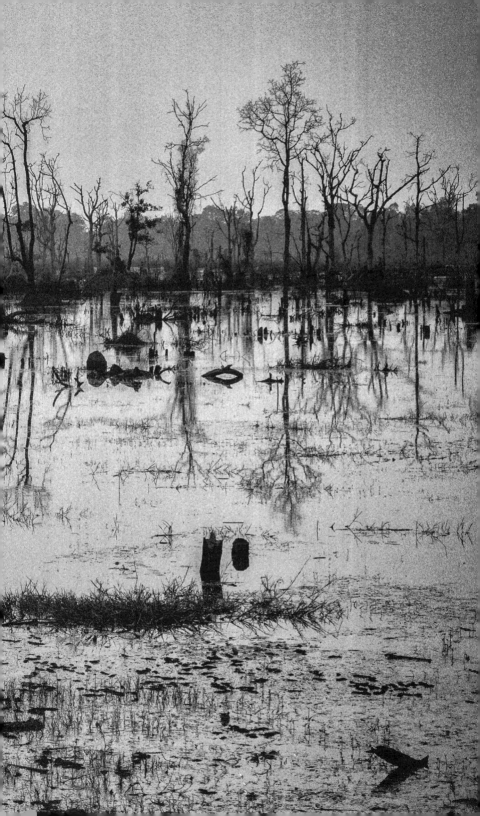

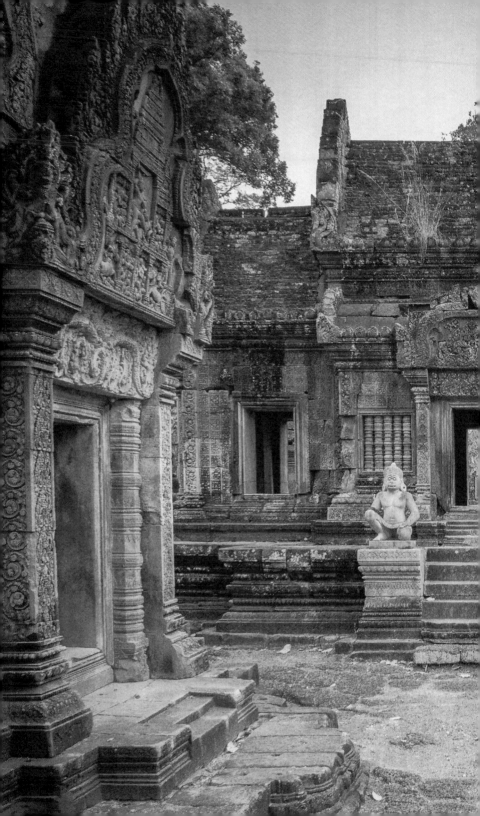

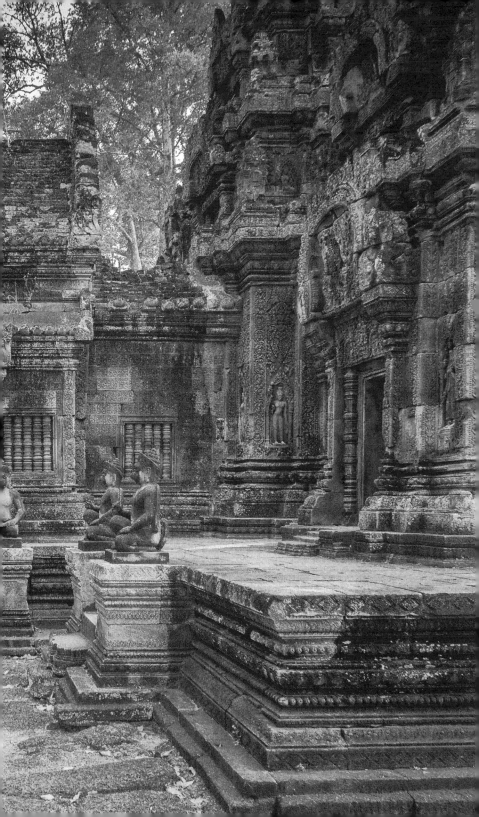

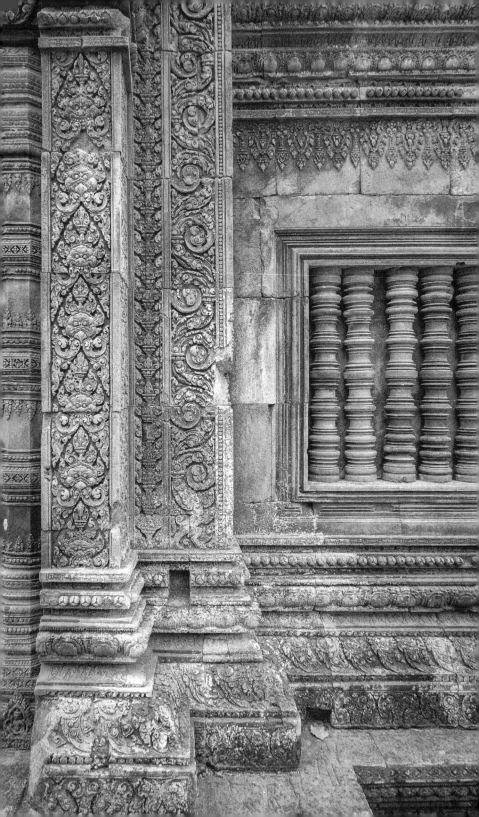

threefold world

great lord of the threefold world

gather your sweeping hair

and tell us of mount Kailash

mountain abode where you balance

eternal om on the navel of the universe

wrung from the churning sea

not all temples are built by kings

royal citadels to honor gods

under the guise of heaven on earth

not all choices are based on worth

emotions pitted against thought

vying for balance within mind

and the enceinte of humankind

amid Shiva simulacrum

carved in delicate rouge sandstone

ganas guarding sanctuary

—lion, Garuda, monkey, Yaksha—

occupying liminal thresholds

where higher forms of consciousness

emanate from smokey shrines

and the burrowing realms of

desire, form, and formlessness

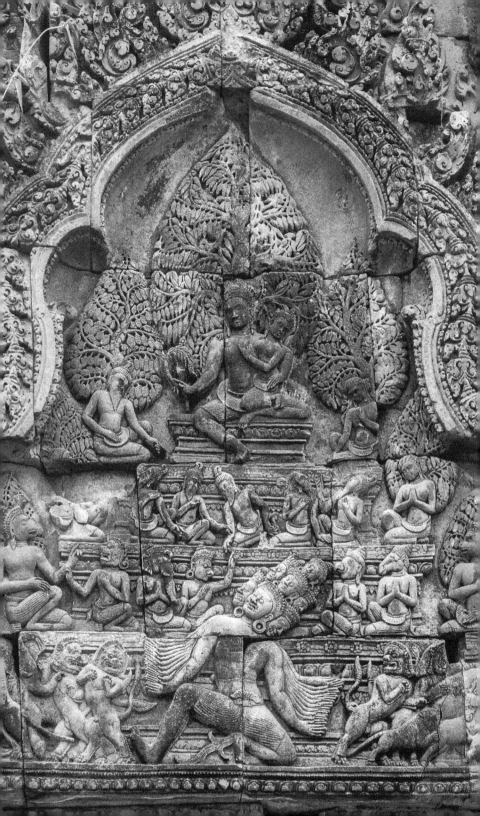

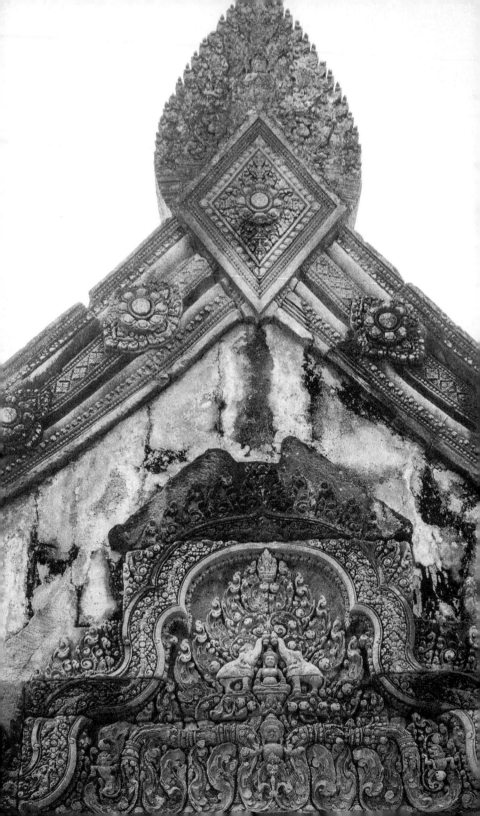

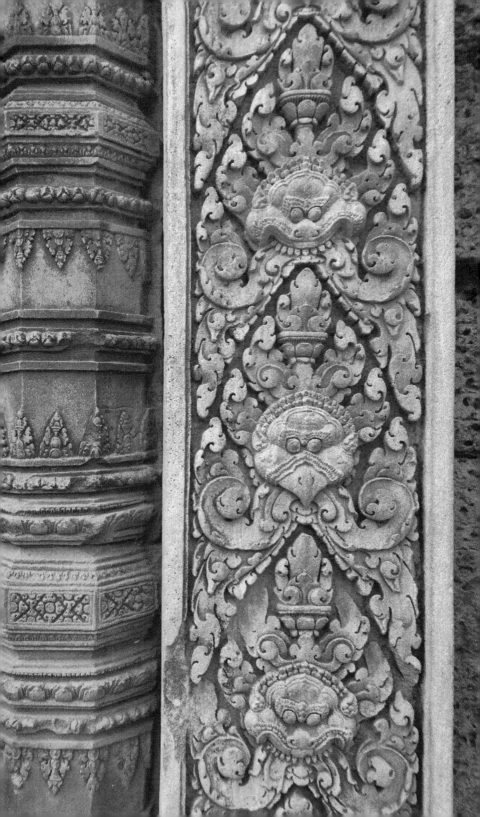

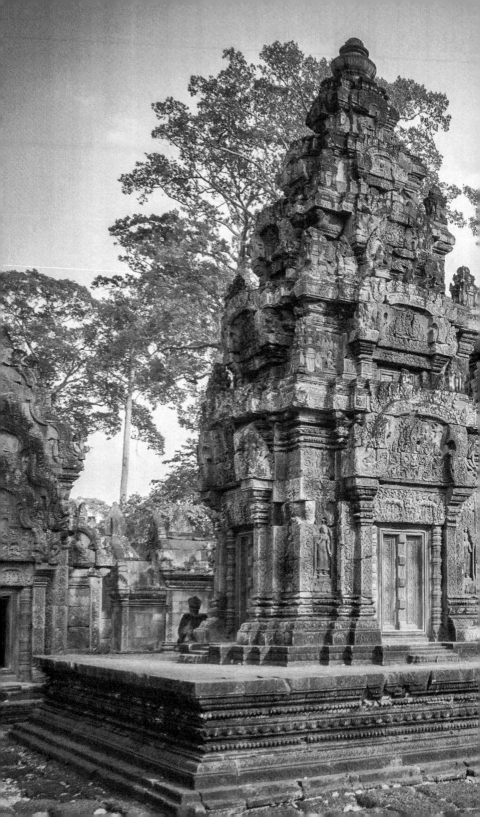

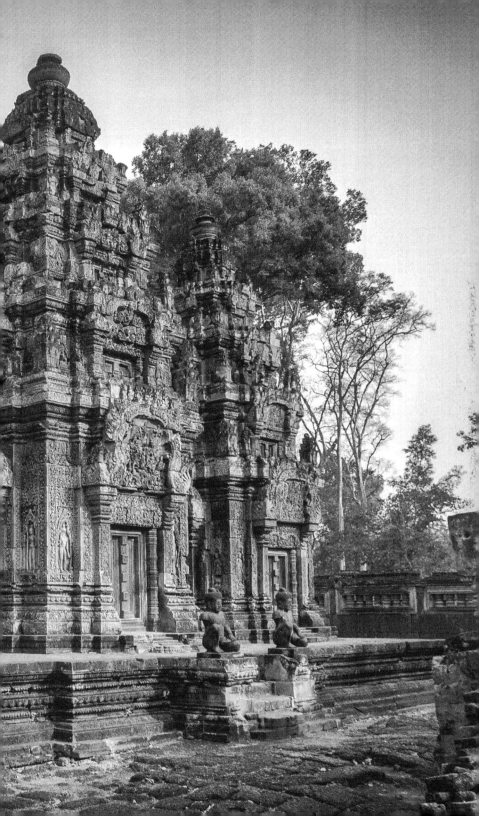

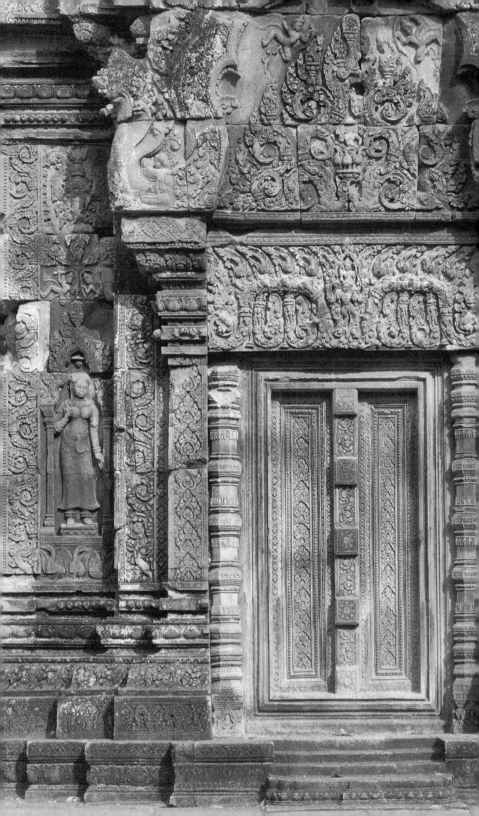

ii
מ

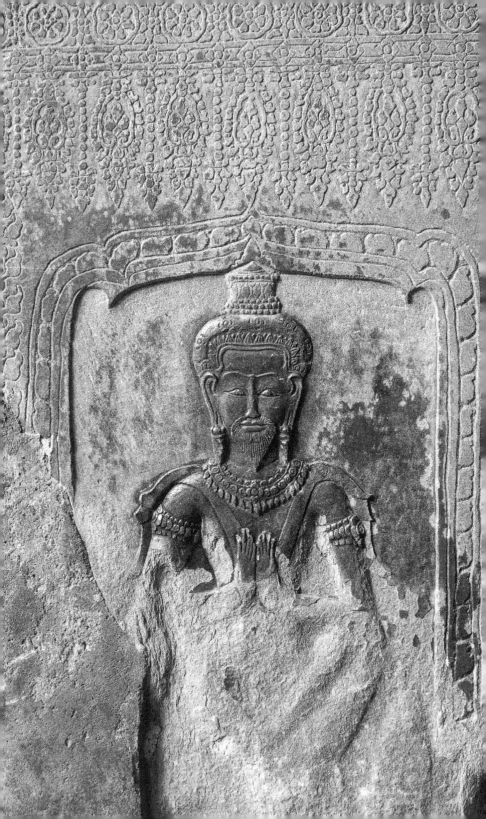

human mind

eyes closed—contemplation—

i listen to sounds of ancient dance

call me

subtle rise of breath

movement spreads effortlessly

through time

where Buddha's ephemeral caress

evaporates like gamelan echoes across

crumbled temples

and human mind

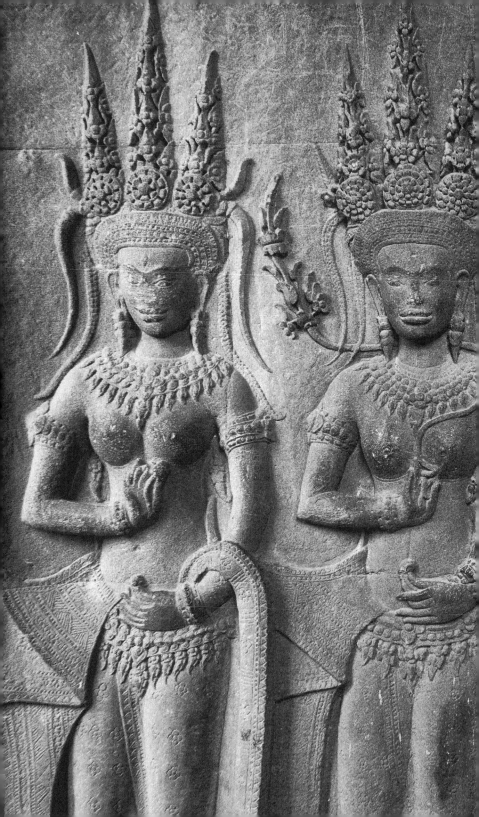

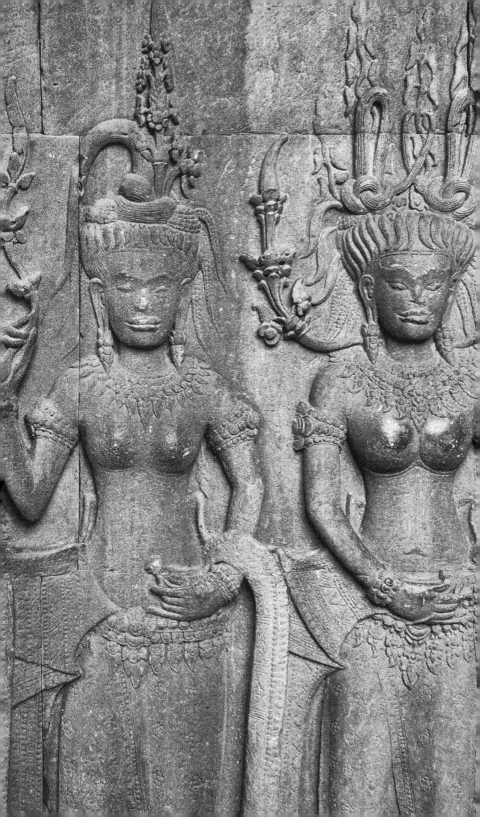

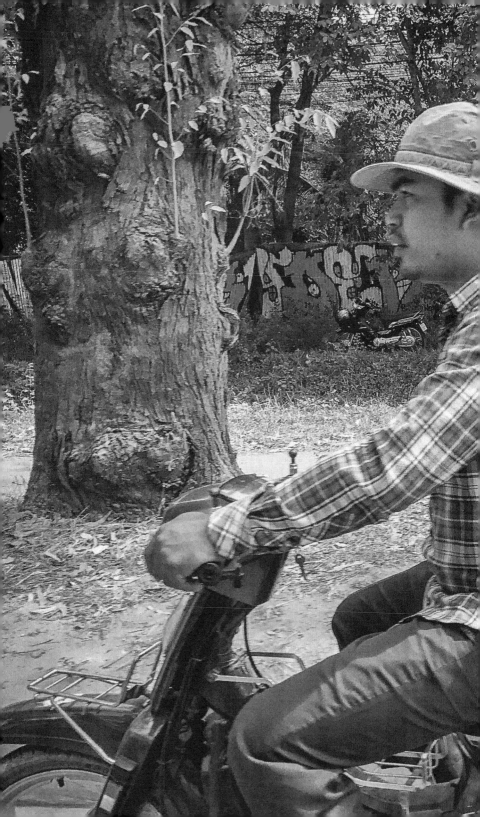

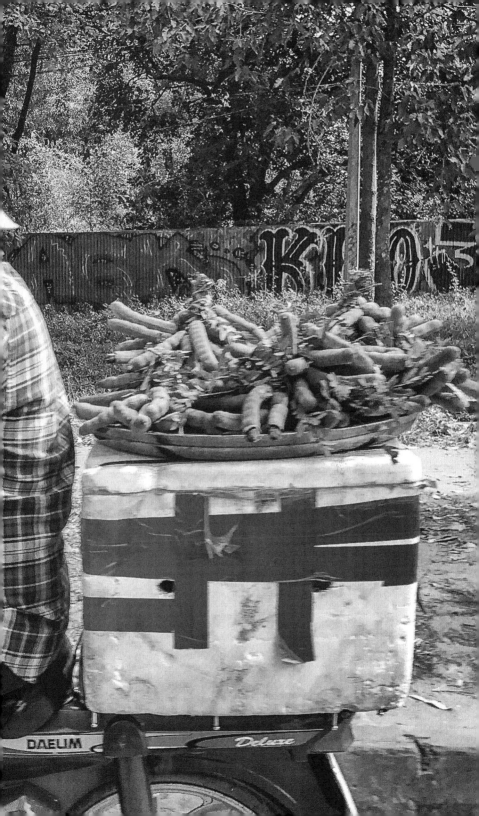

dusty adventure

motorbike and scooter

are typical modes

of transportation in Cambodia

it's how everyone

gets around

whether countryside or town

it's the best way to discover

almost any place

in the country

many people can ride

if we need room

for a friend or two

carrying children?

four adults and one motorbike?

we'll make room for all!

there are many ways to ride

don't like to straddle?

sit to the side

it doesn't matter

just—optionally—

hold on tight!

have something to carry?

good for that too!

we can strap it on

balance it just so

or hold it in your hands

as we go

it's easy to get

where we're going

just remember

traffic lanes

as we know them

are suggestions at best here

even roads are suggestions

now that i mention it

every day is a dusty adventure

we can get around

just fine

in Cambodia

on a motorbike

or scooter

no matter where we go

and we'll have a blast doing it

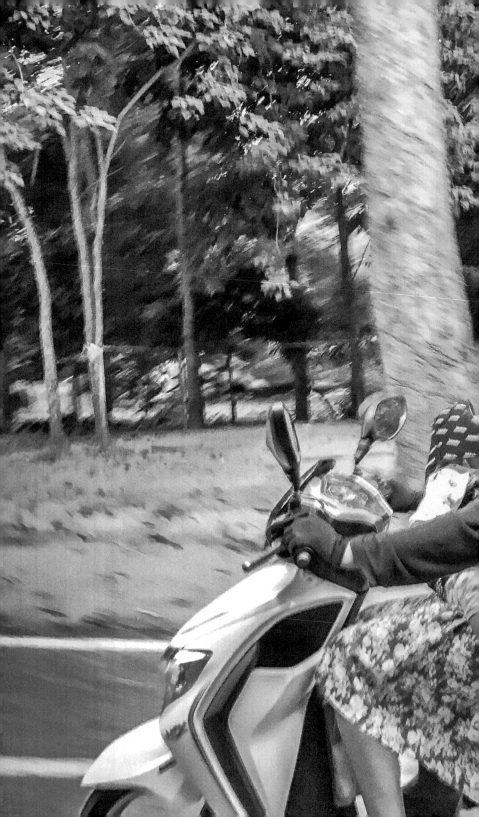

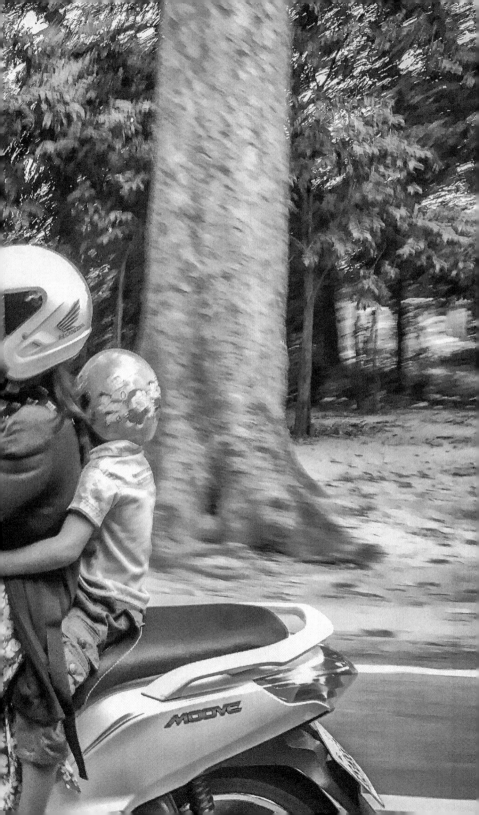

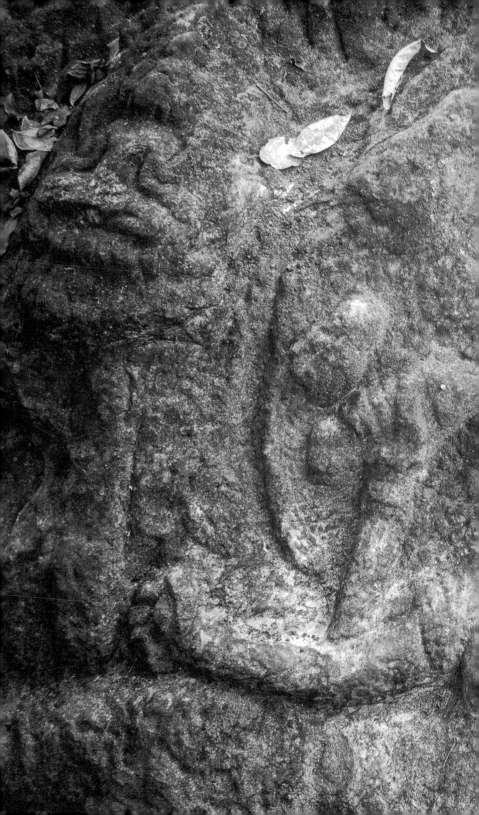

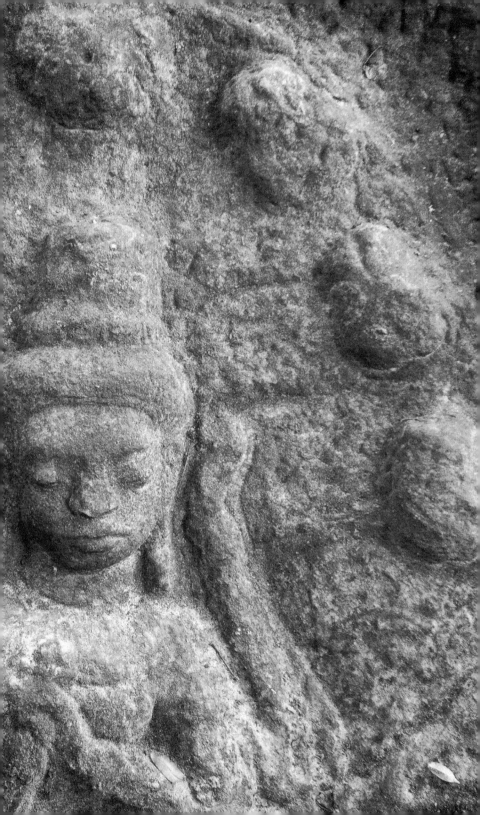

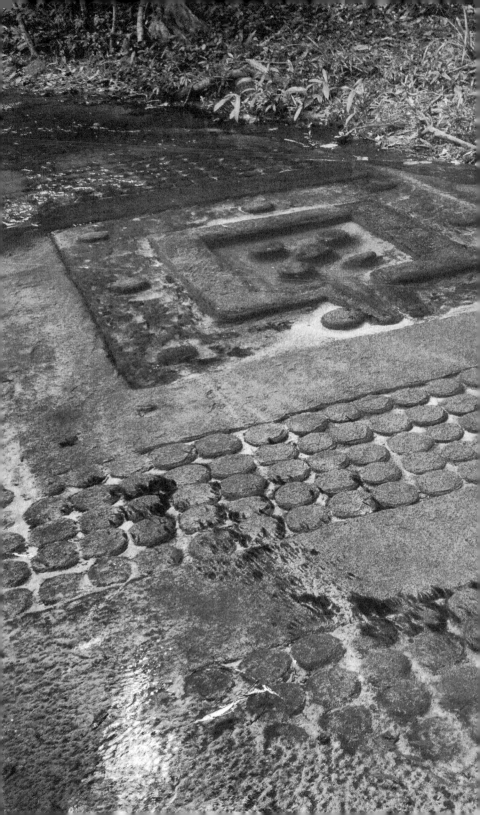

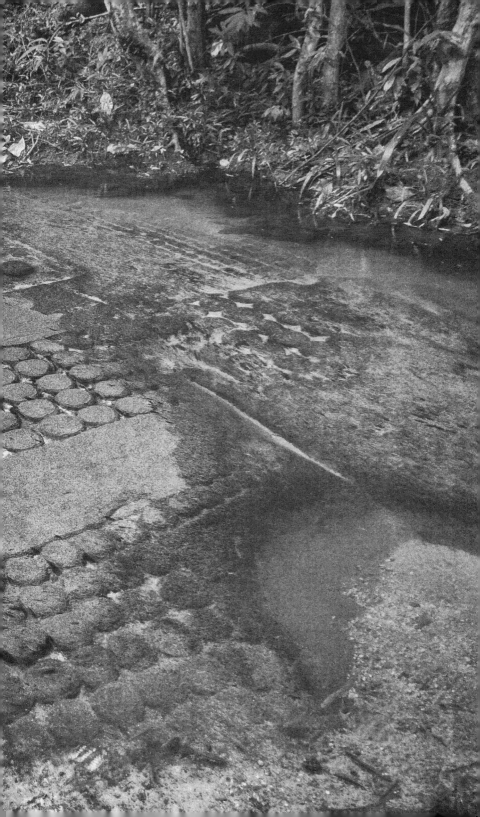

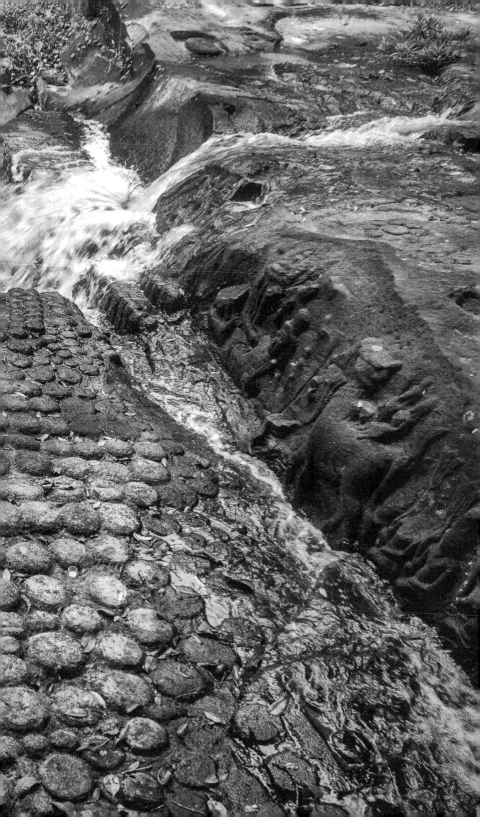

eternal spiral

on mount Kulen

there is a fount pouring

a crystal spring bubbling up

—holy water—

i wash my head praying

water flows down mountain

riverbeds of ancient lingam

carved 1,000 years ago

for today's wish

falling down the mountain

cascading rhythm fresh

warming under Vishnu's sun

fertile healing whispers of fish

nibble my legs and smooth my skin

blessed waters of Shiva falling

cicada rhythm eternal vibration

calling through forest drone

echoing chants of infinite ommm

the jungle is home to many:

jungle sustains, jungle remains

forever constant, forever changed

water flows

from the fountain

life given for trees and streams

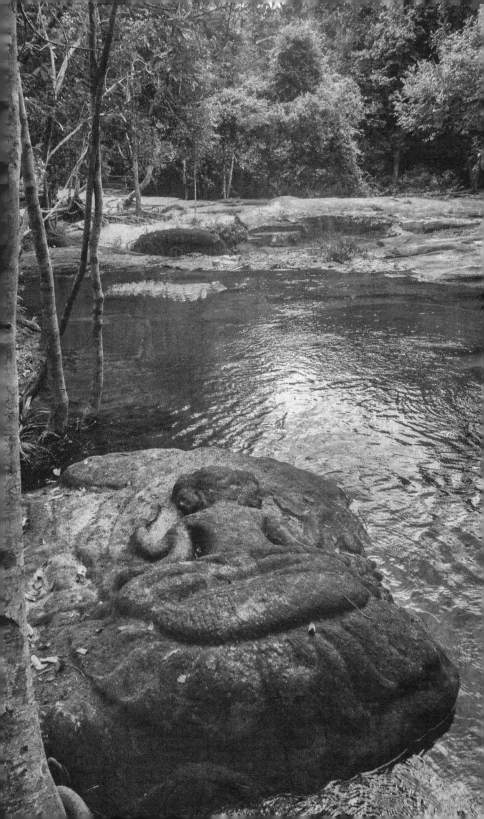

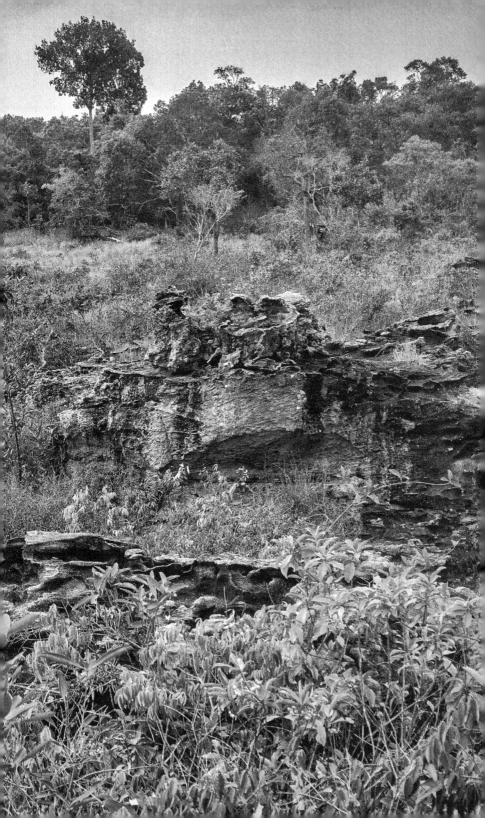

there are many worlds

on the mountain

both visible and unknown

sandy paths spread across stone

craggy boulders punctuate landscape

like the surface of a distant planet

if you know where to look

you can find mushrooms

or more to eat

there are many foods

on the mountain

tromoung, for a sour, sour soup

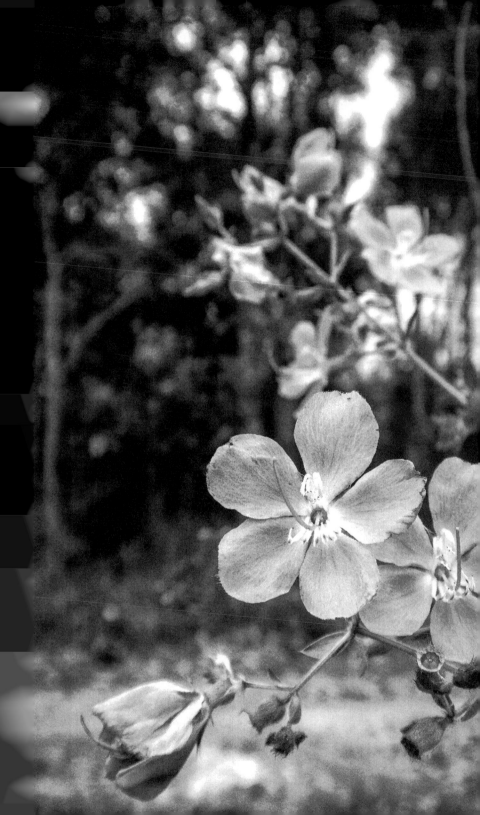

trauy reang is good in a fry

small pods of plerr reak

—taste like beans—delicious treat—

plerr pnek kong kepp

—so sweet—

round like eyes of frog

there are many flowers

on the mountain

beautiful to see

paintbrush of nature

vivid color among

dense brush

an offering

that must be seen

to be believed

there is a place—deep—

in the jungle where elephants

gather with lions

keep watch over the mountain

—temple to nature—

standing guard

waiting in silence

remembering the day

when they roamed the forest

wandering through dark places

beneath a canopy of vines

twisted slowly

while the hand of trees

—climb—

eternal spirals

and reach toward heaven

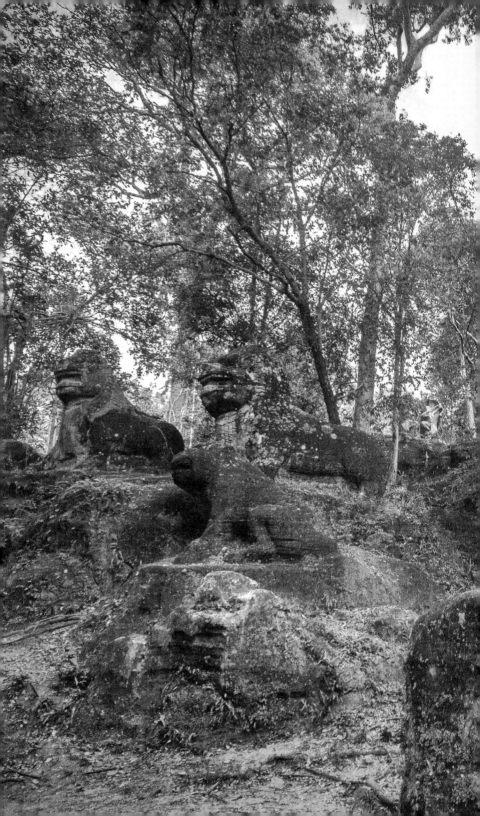

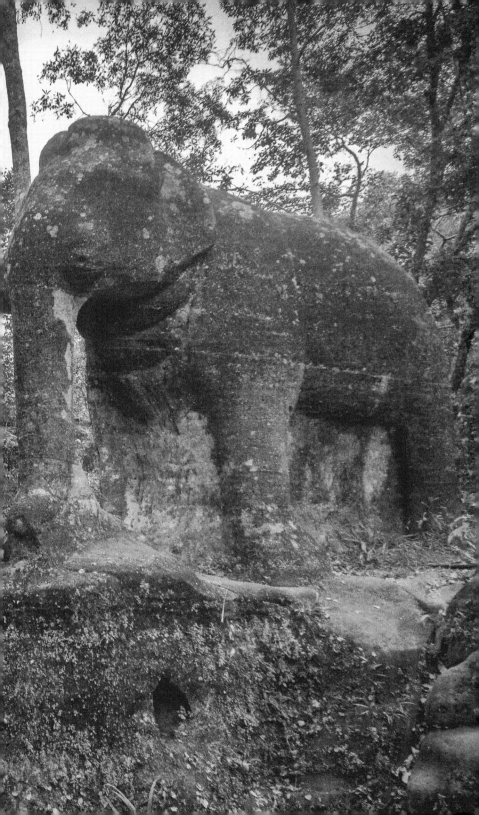

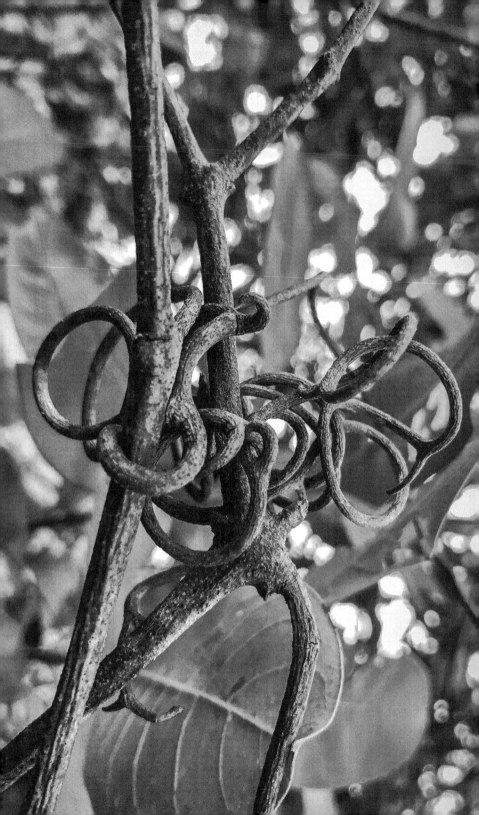

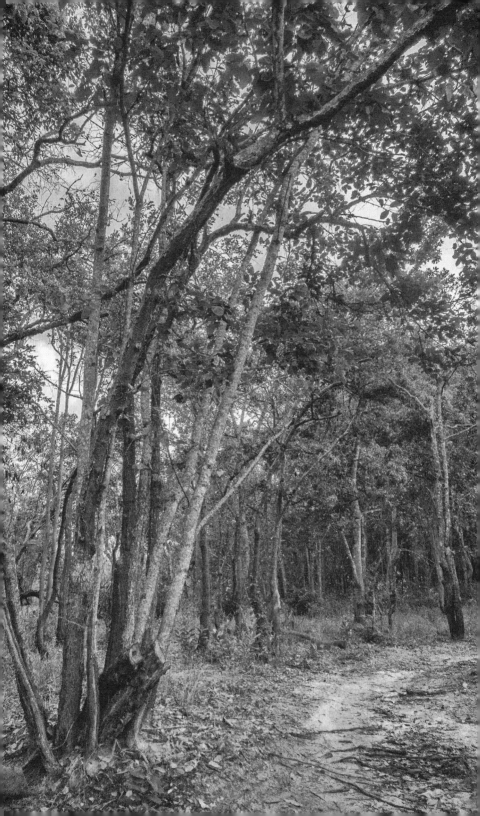

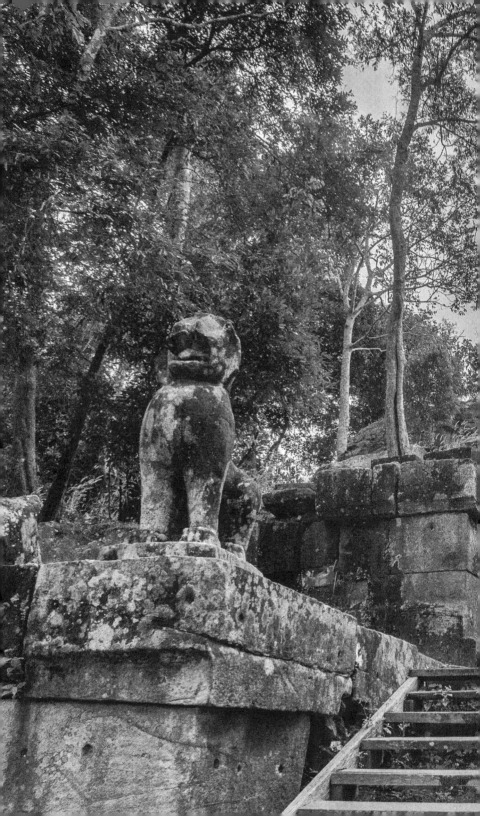

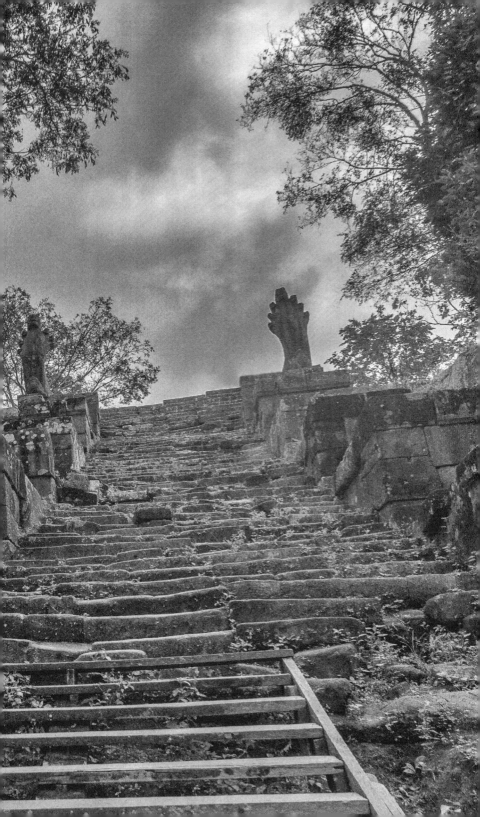

mountain abode

i come from far away

to the other side of the world

and ascend to heaven

lions paw the earth welcoming

all who make the journey here

to join the rising spiral

oh Preah Vihear, listen to prayers

of Khmer rising over your cliffs

and hear groaning cries

the bleeding heart of Cambodia

under longsuffering darkness

clawing up Pey Tadi

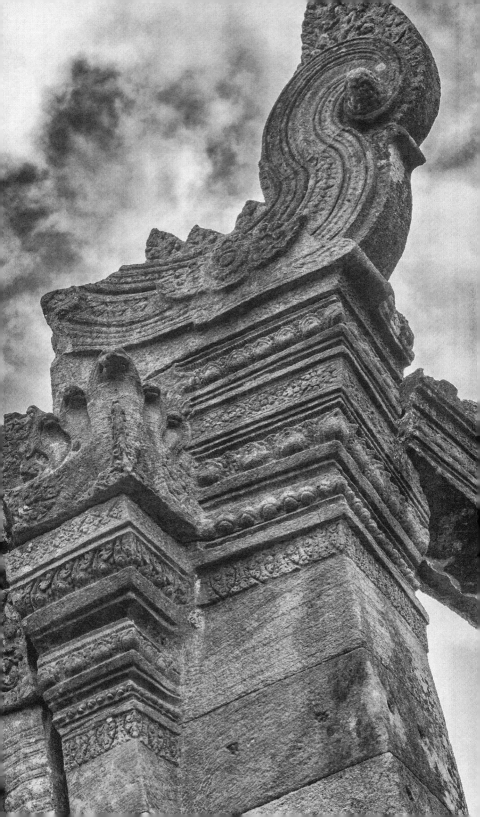

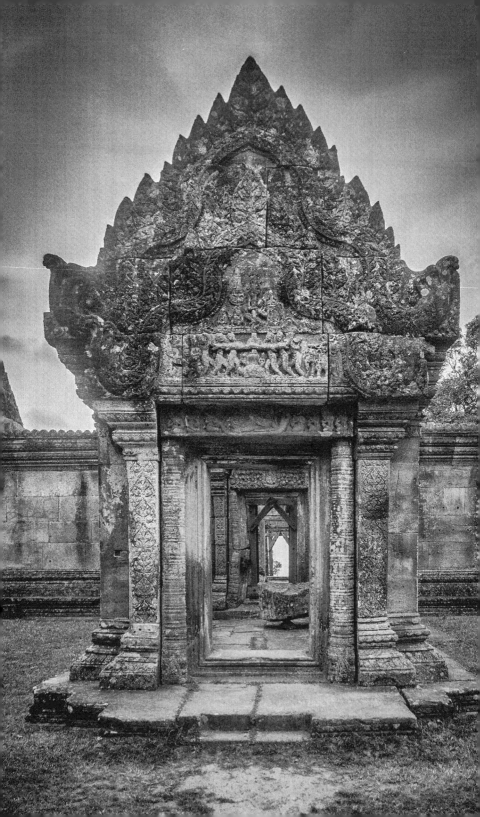

here rest heavenly disputes

where men and gods refute

the borders of your sanctuary

across gunfire and

gopuras gleaming

under golden skies

your avenue lanes

show the way

among bunkers and Brahman

oh Preah Vihear, hear the cry

of your people suffering

and the burden of your mountain abode

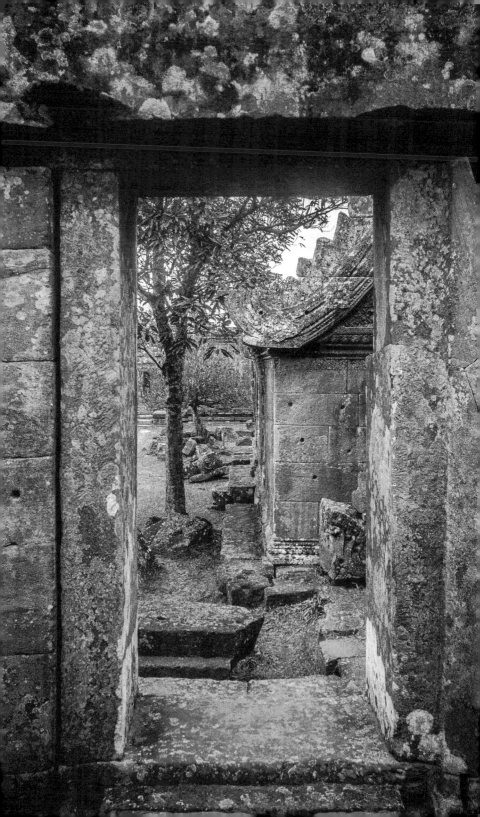

there is no conflict in your soul

the architecture of your temples

balance delicate harmony

nestled against heaven's belly

a gentle brush across the face

as Shiva's hair swirls around my head

oh Preah Vihear, it is said

your holy sanctum—temple in the clouds—

is a celestial portal future portend

i walk into a dark room

kneel at the feet of Ganesha

send up prayers for poetry and peace

that fighting may end—wars cease—

and consciousness may rise

above these lofty plains

oh Preah Vihear, the pain of change

comes from holding on too tight

a feeble mind unwilling to bend

until the dark moment it breaks

i do not partake in fear

i do not partake in hate

i turn and greet two young monks

"how are you?" i ask

but they do not speak English

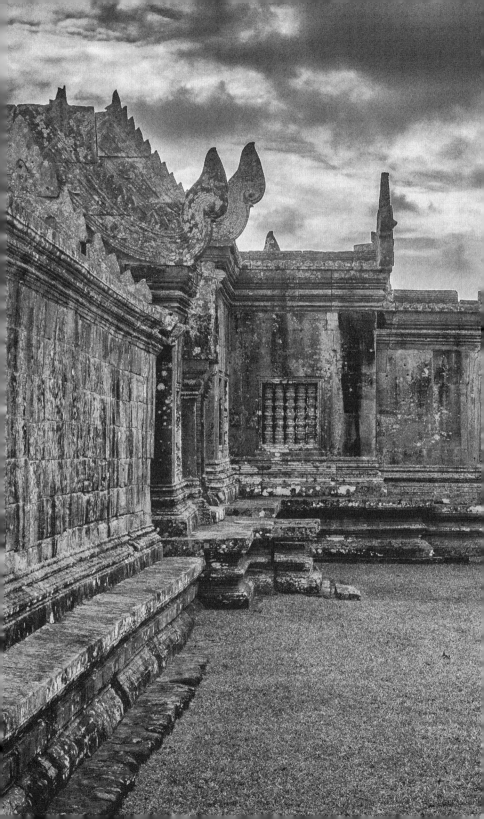

so we converse in smiles now

language unnecessary

in these realms

i nod and join hands at my brow

thankful these men

tend to this place

oh Preah Vihear, what faith!

the face of your vertical cliffs support

temple walls and spiritual life to hold up

heaven's sun so bright

here on this mountain where

gods themselves reside

and humans try to understand

war waged among the sky

and the mysterious ways we fight

oh Preah Vihear, the light!

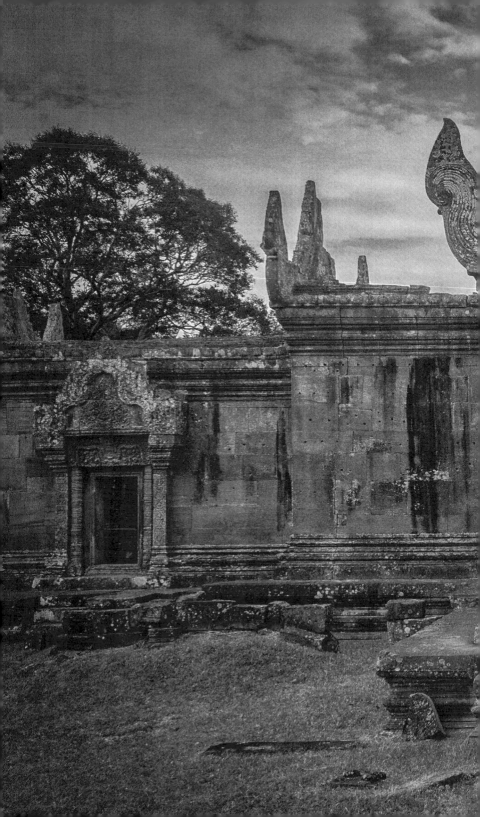

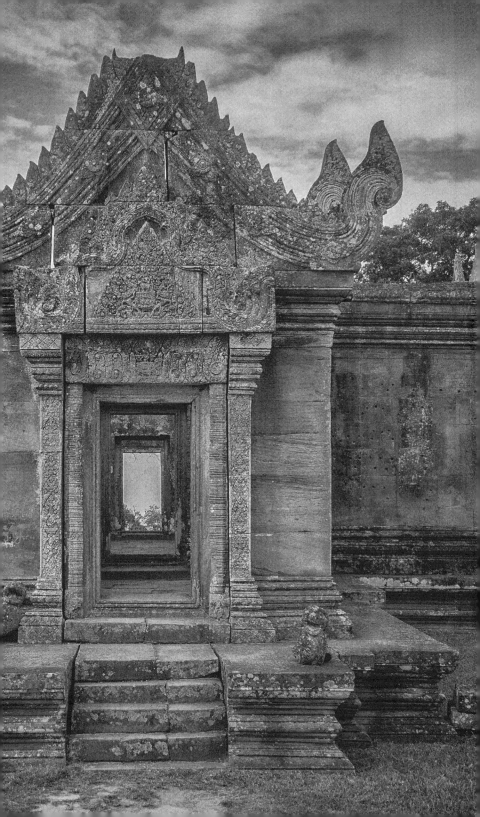

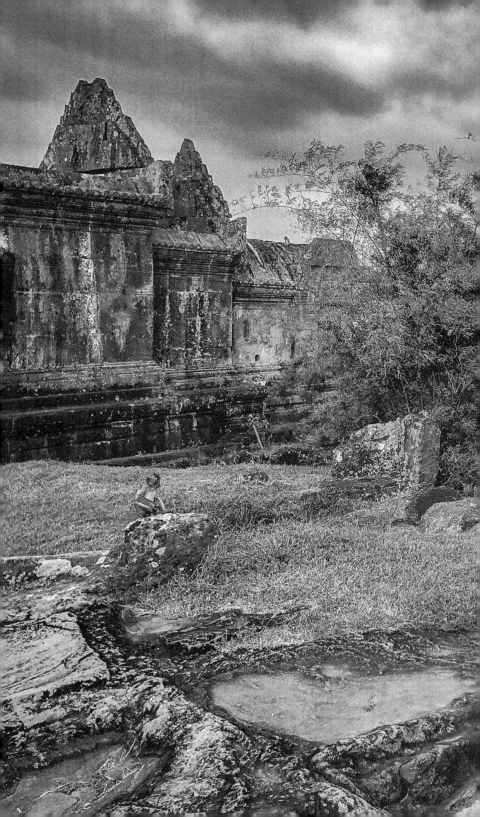

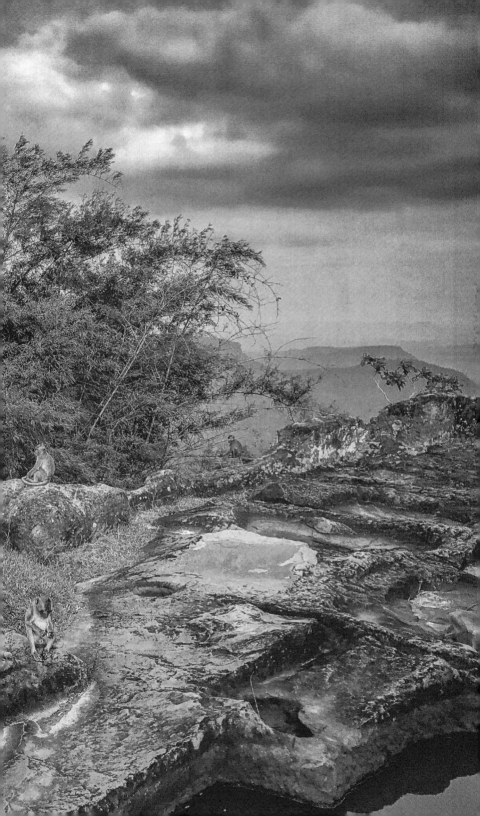

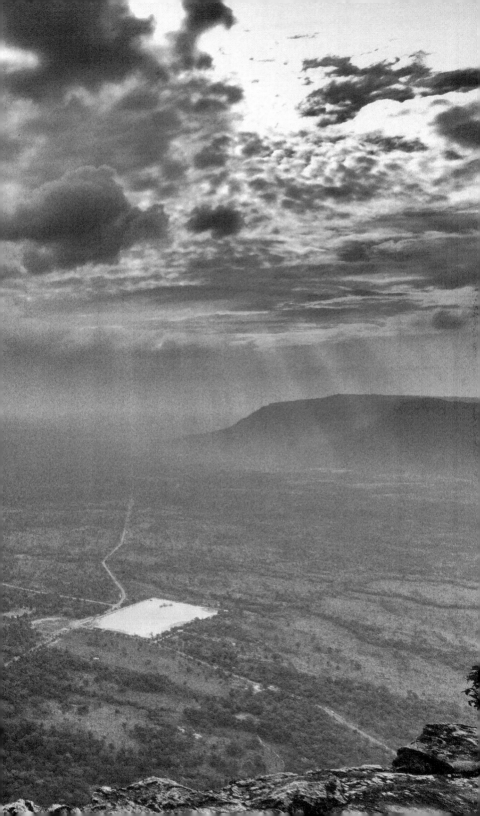

zero year

turn back the wheel of time

before contemptuous autogenocide

crawling backwards without feet

did you ever think you would see

such brutalmurderoushate

in your own backyard garden?

my hand quivers with disgust

over inhuman attacks

insane convictions

brainwashed systems

of crime and punishment

scattered about a landmine landscape

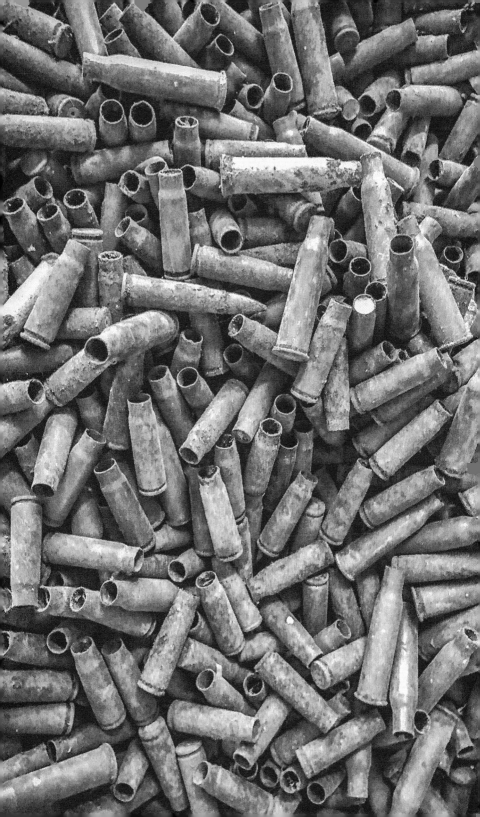

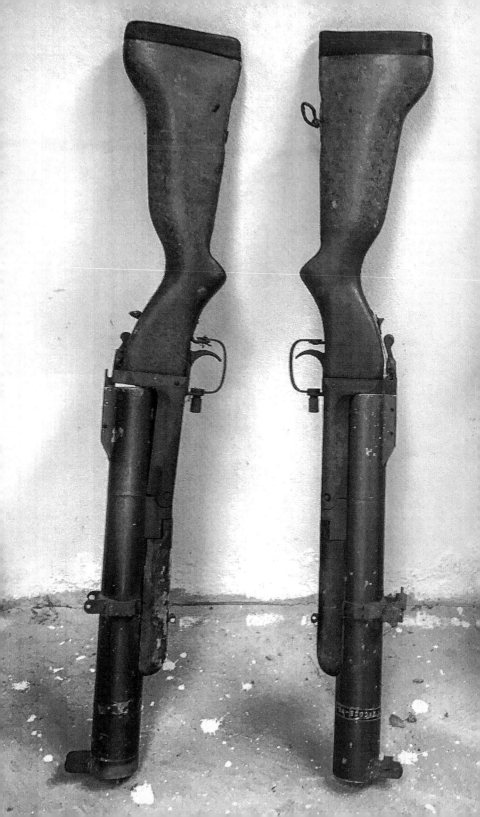

where dualities of hate

are pitted against oneness

and you must fight or die

forced against a wall

where smashing guerrilla warriors cry

for a bold and treacherous marriage

holed up in spiritual halls

for a military garrison

fortified under stones

crumbling gods and demons

wage battle long

—have the demons won?

invasion does not always come from afar

sometimes it comes from within

under siege and unwilling

fields become places of killing

where bodies drain into earth

crying rivers of groaning lament

there is no crop to harvest

from this land—packed—

with blood and sand

bleeding bright under sun

of burning rot for days

how could anyone have thought

this destructive blaze

could be wrought

amid ancient temples so grand

did Shiva

—dance—

upon this land?

turn forward the wheel of time

but always remember year zero

so that future—generations—

may learn from our mistakes

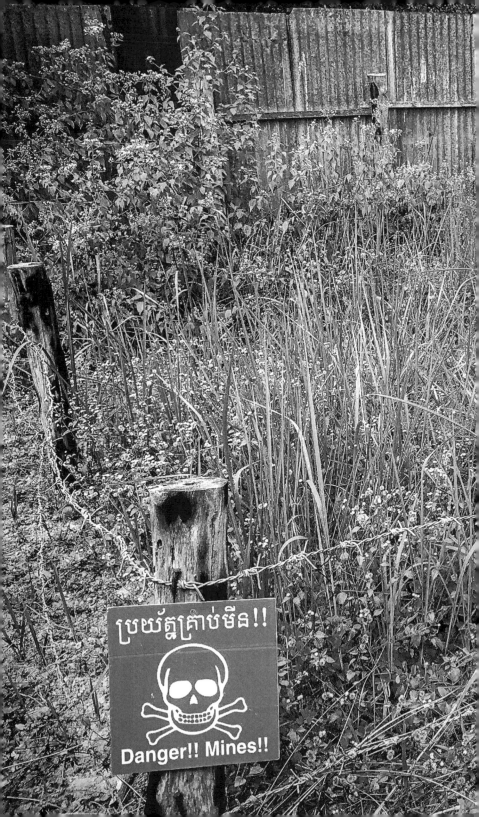

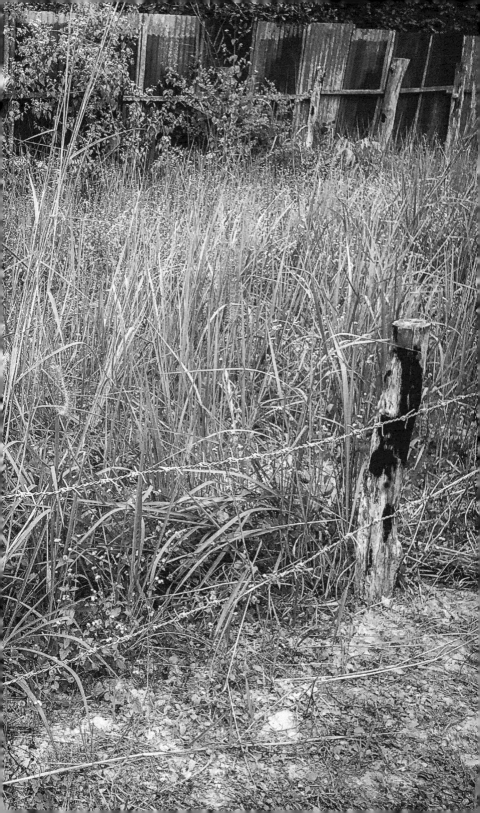

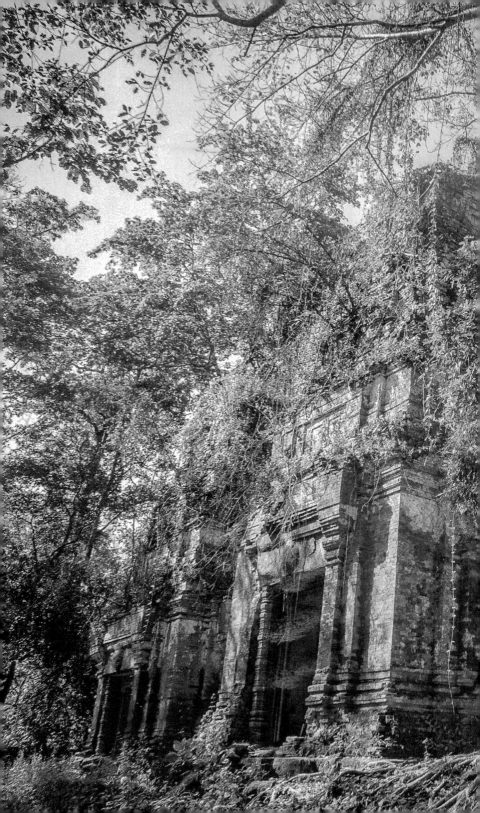

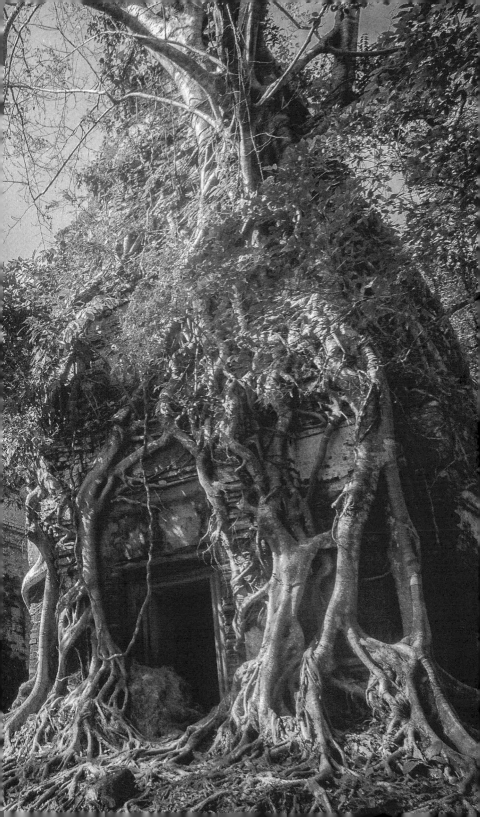

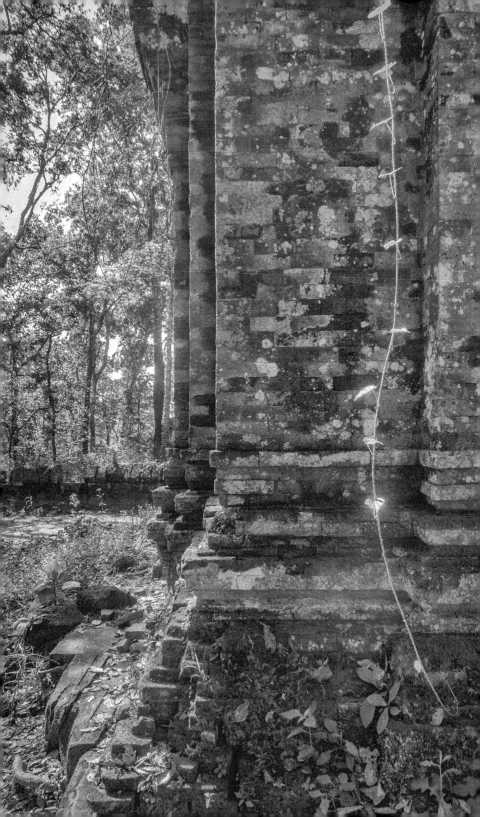

red blood

Koh Ker Koh Ker Koh Ker

there are a hundred temples

deep within the jungle there

your red clay roads remind me of home

deep in the Georgia countryside

where the soil bleeds Cherokee blood

and deep in the mud is baked

a litany for the great people

who marched away in tears

after all these years and miles

i am here in Cambodia

country that has captured my heart

the art of a temple is complex

whether miniature buildings baked in the sun

driven into the black of night

or carvings nestled by holy water

—Vishnu, Shiva, Brahma—

sinking in earth, worn by monsoon rain

oh Koh Ker Koh Ker the pain

of descending into the past

where light struggles to penetrate jungle canopy

and ponds are thick with reeds

where you can step both feet and

walk on holy water

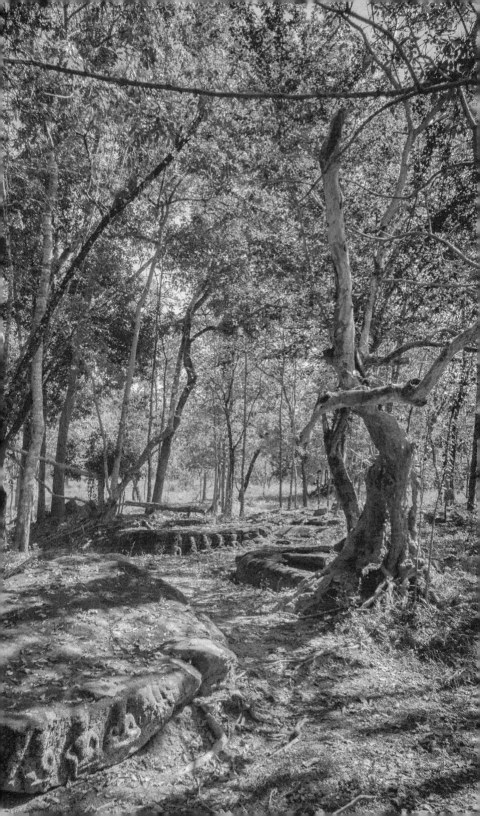

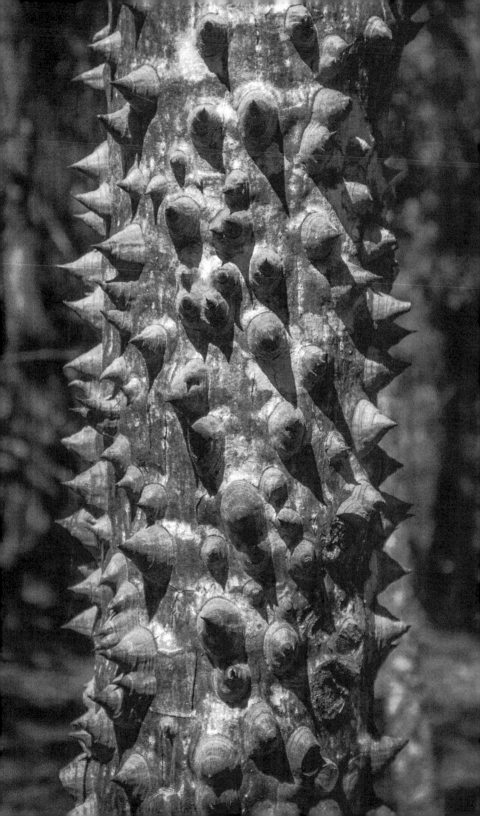

but the miracles of Koh Ker

are not without punishment

for it is the way of the jungle

beware the scorpion, beware the tarantula

beware the deoum rokar, tree so hard

with thorns sharp as blades of steel

but there are also ways to heal in the jungle

like the leaf of war-knog that knows

ways to sooth the churning

i come to the jungle for learning

the ancient ways of calming mind and body

away from the spoils of modern life

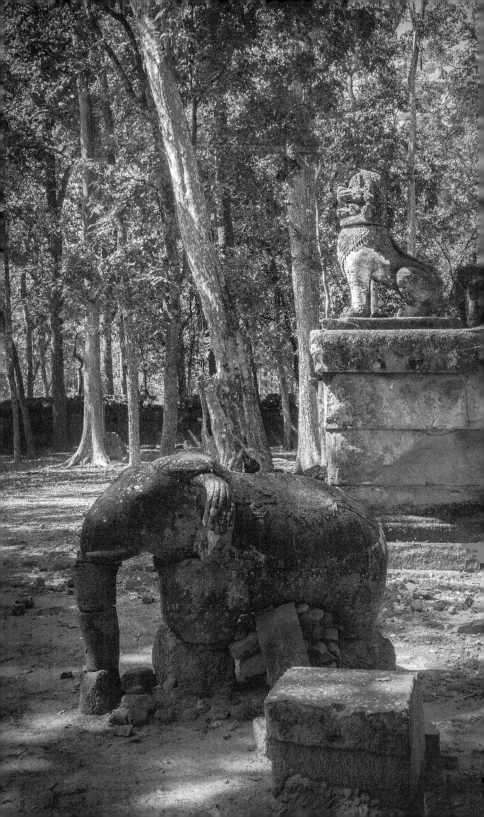

Koh Ker Koh Ker Koh Ker

share your secrets as we pour water

upon your lingam and wash away the

red blood of the past

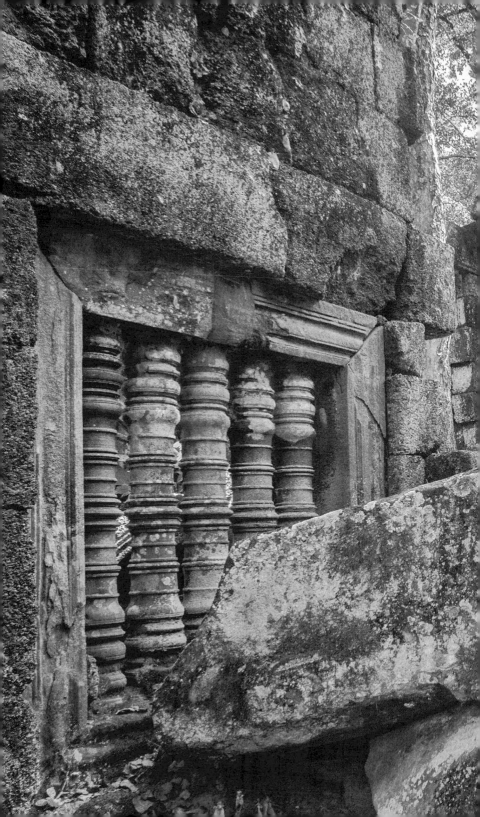

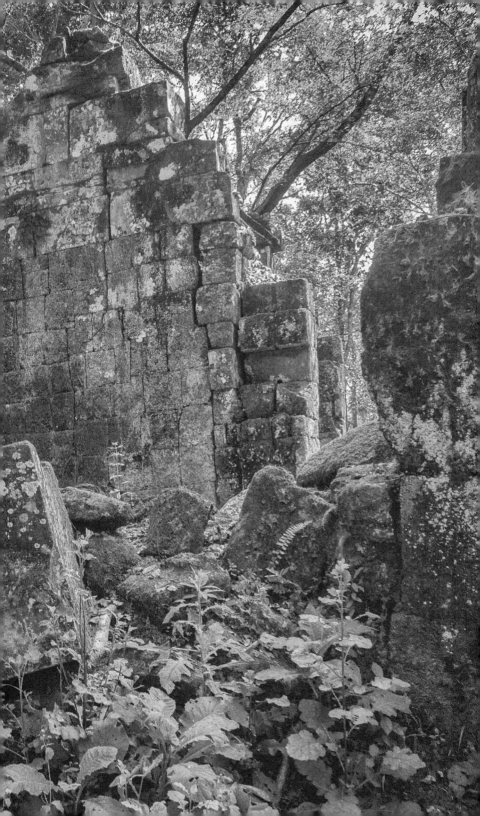

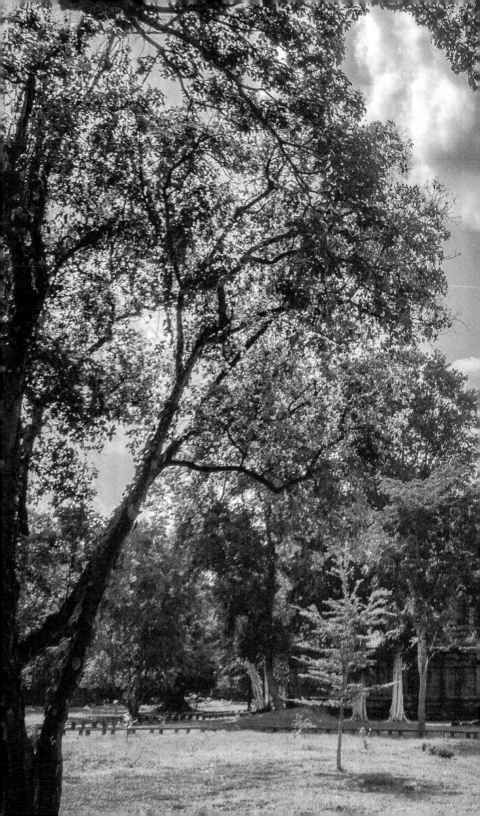

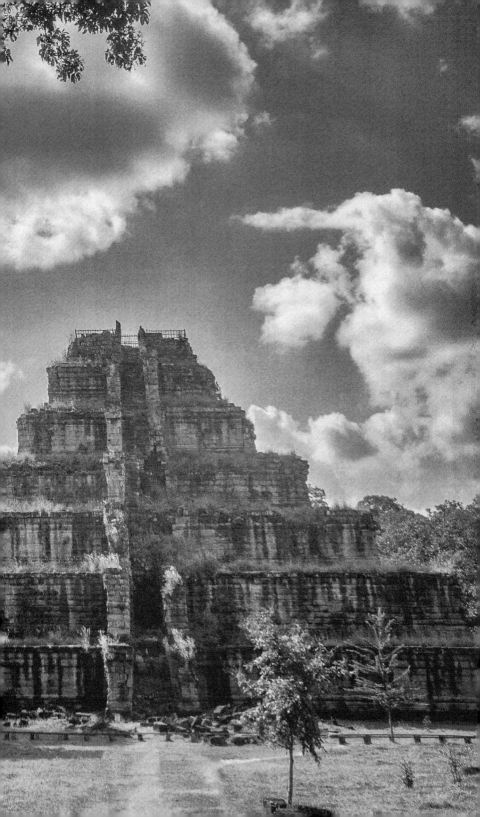

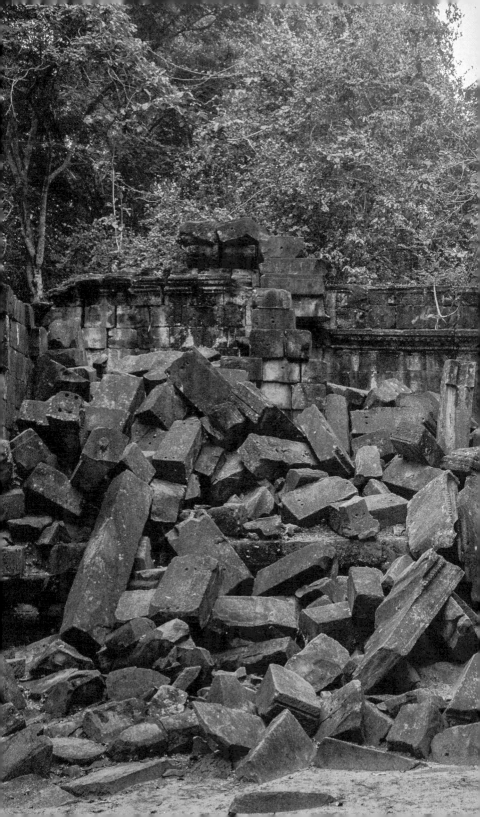

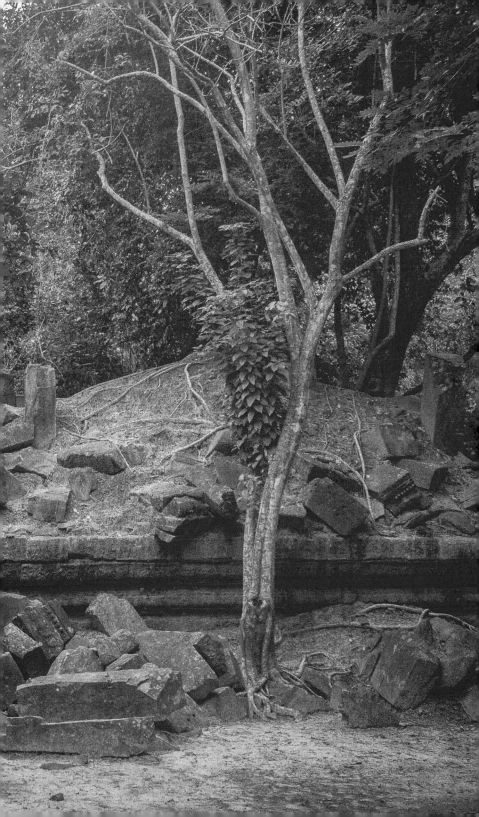

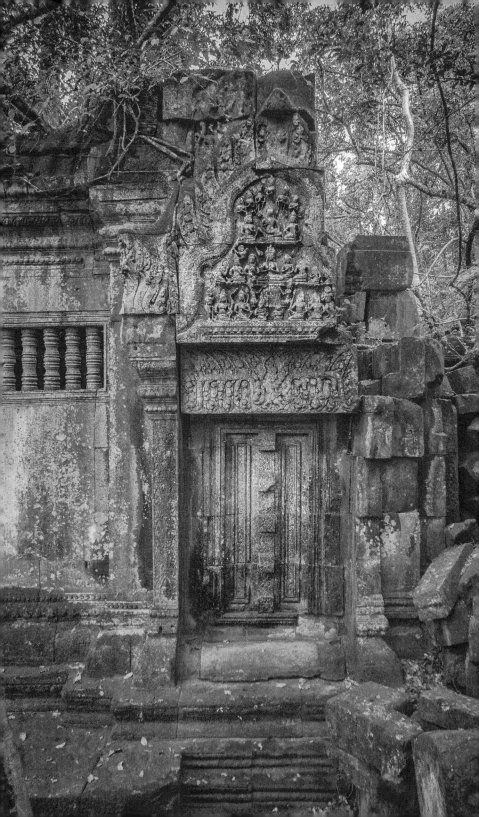

tender heart

civilization is not an undying reign

neither to the ancients

nor in modern days

impermanent institutions crumble

melting the passage of time

—kingdoms cease—

this release of energy

is part of the sacred spiral

upon which we travel

slowly time will unravel

broken glass floating

to the surface

a cycle reincarnate

programmed like DNA

intrinsic instincts encoded

do you know the way

through collapsed galleries

and dark corridors?

there is a human urge

to rebuild crumbled ruins

and revive entombed splendor

yet metaphysical truth resides

in the tender heart

—not lofty temples—

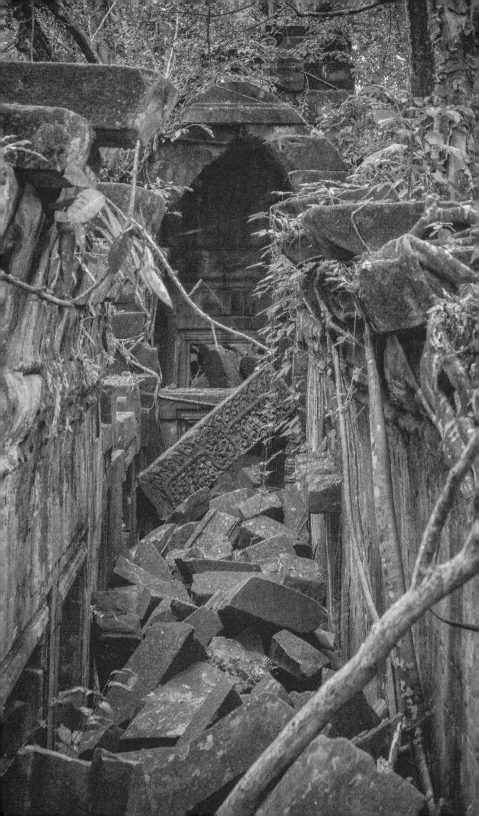

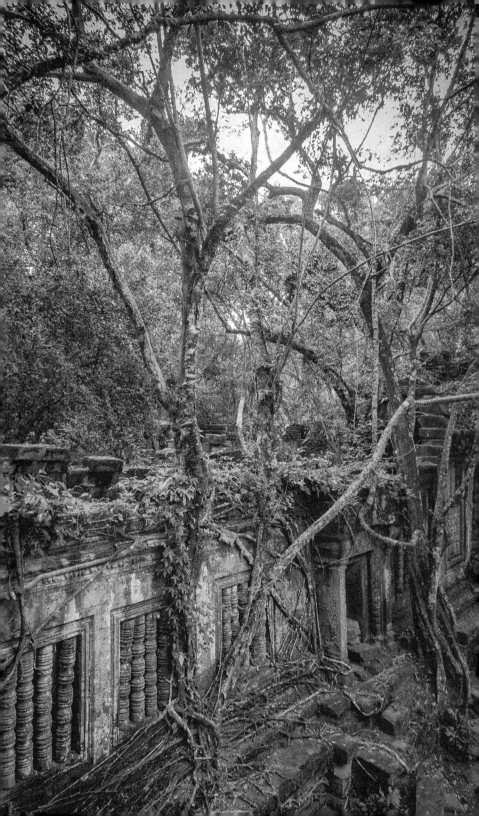

like lotus emerging

born from muddy pools

dense with murky water

rising toward the light

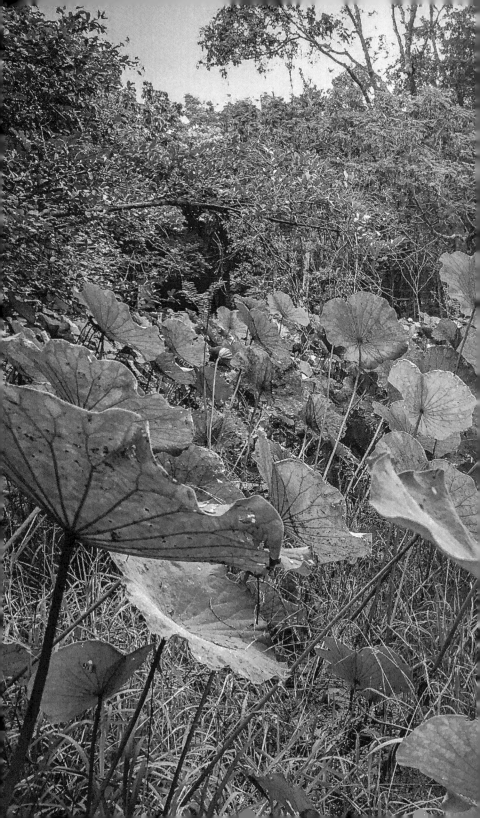

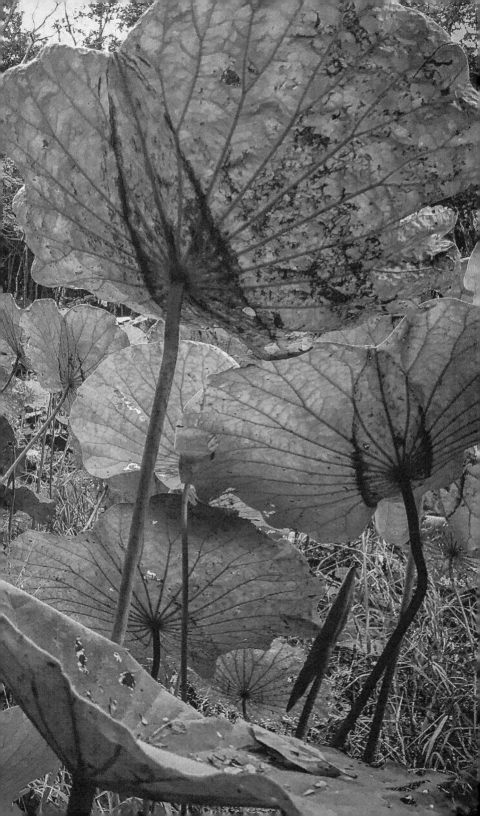

apsara dance

the night market is full

of things to buy

treasures to try

and negotiate a good price

to find something nice

for back home

statues of Buddha

silver animals

paintings of Ta Prohm

pair of Thepphanom

temple rubbing on paper

made of rice

"i give you good price"

she says as you glance

unsure of this dance

afraid to look closely

for fear of committing

to an unwanted purchase

she searches your face

begins the dance

no matter if you want her to

"twenty dollar for you"

she says with a smile

twirl of the wrist

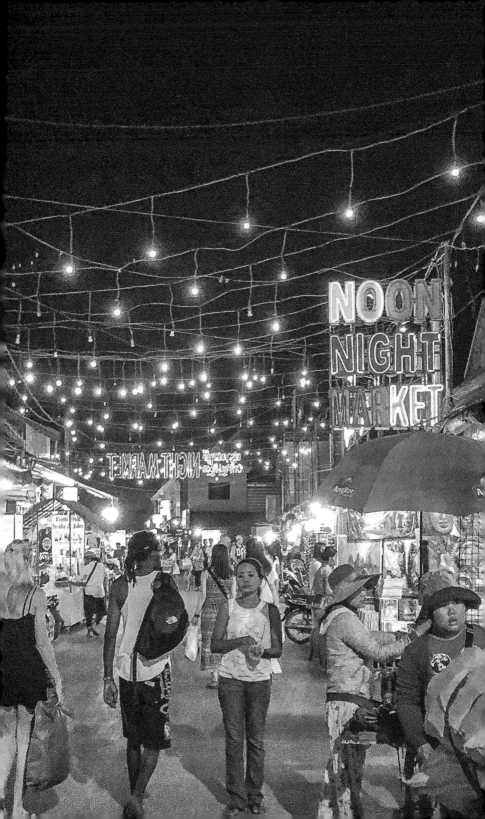

"how about ten?" you insist

shuffling your feet, she bows

and replies "fifteen" with a laugh

you offer a grin

a subtle sashay

she says "how about twelve"

trying to make the sell

her hips sway

with a curve of the lips

"ok, it's a deal"

and you make the transaction

the dance, the action

of night market shopping

the intimate waltzing

as you go on walking

laughing and talking

exploring the market

for another chance

at the apsara dance

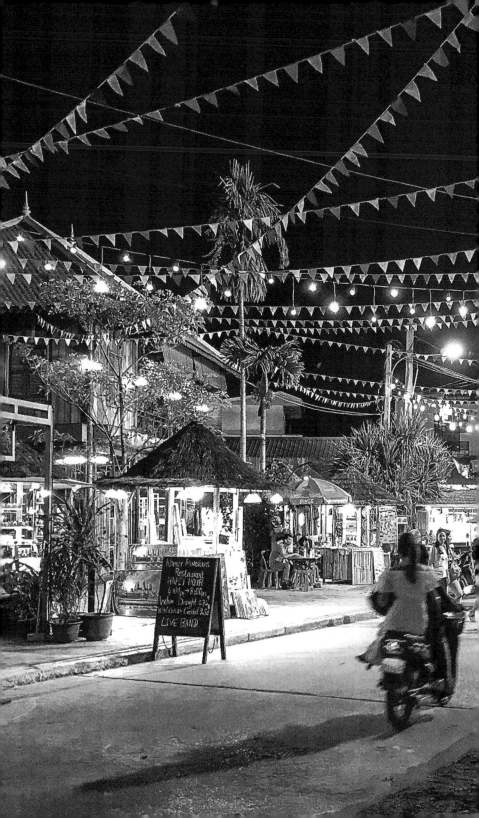

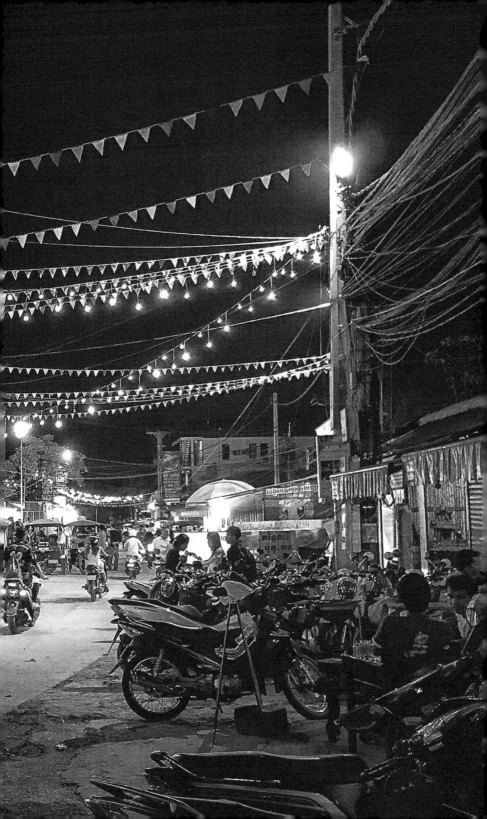

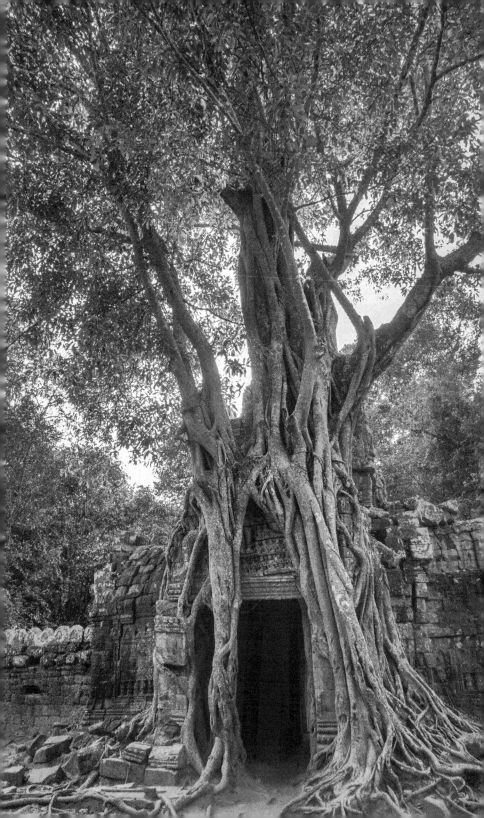

iii

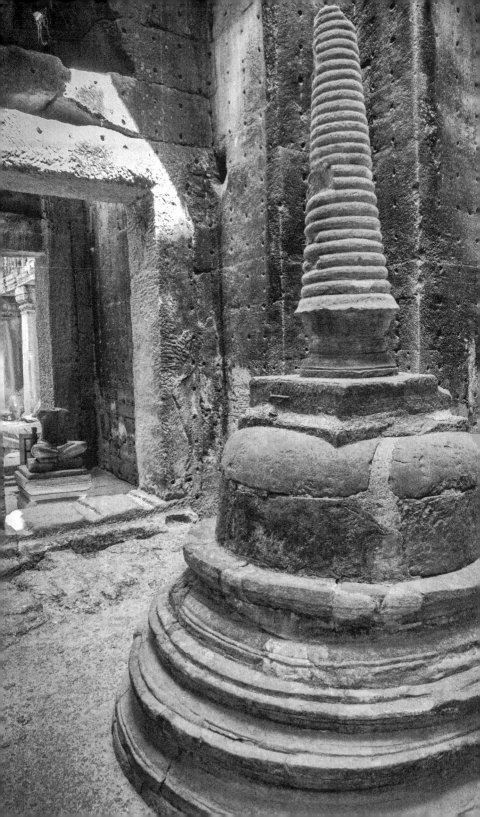

empty cup

empty your mind of all thought

clear away your opinions and

all purpose for pride

the mind is like a cup—

if you fill your cup with dirty water

it is useless and stale

an empty cup hides nothing

always open, still, ready to accept

hot tea for a thirsty soul

content to rest empty again

in the void of non-self

amid the balance of

noble truth

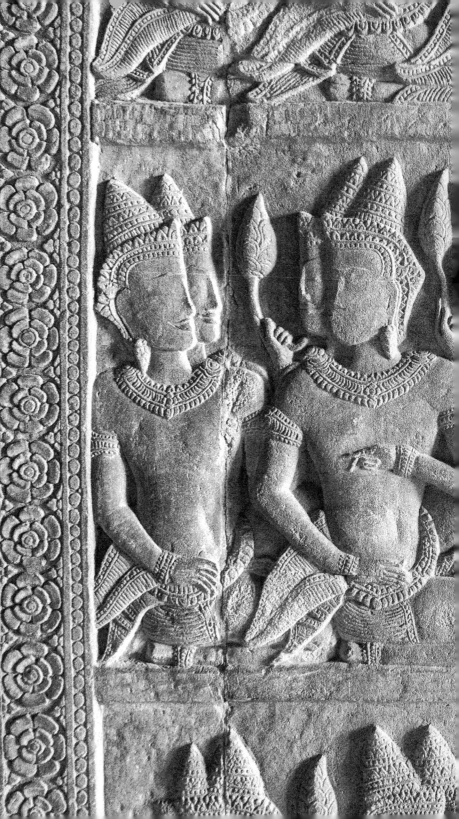

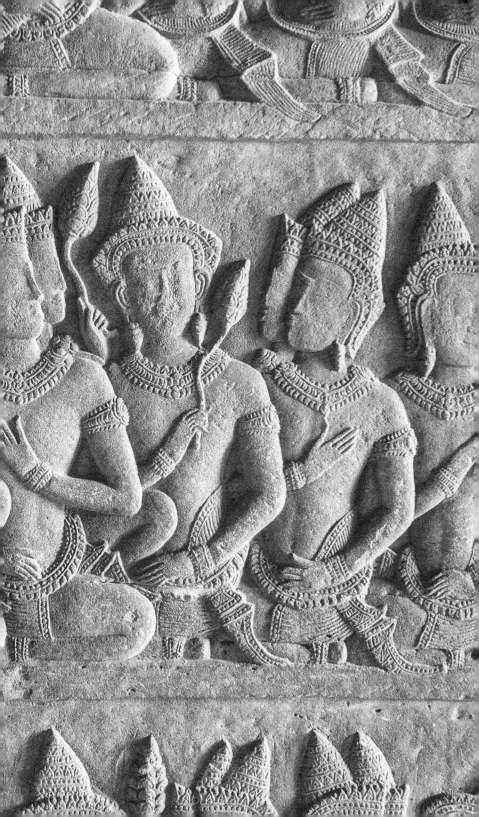

primordial vibration

one dimensional minds learn history

in stories we find layered upon one another

thought beyond time throughout the world

we stretch body and head like thin wrapping

searching out multidimensional energies

of gods and kingdoms colliding

i sit in agnistambhasana and feel fire

connected deep in our planet's core

music composed of galaxies and stars

when i was ten years old i picked up

a basalt stone at Sunset Crater, lava rock

i have and hold even now for primordial vibration

volcano eruption on North American continent

just as the golden age of Khmer was dawning

two dimensions on opposite sides of earth

Europe firmly in medieval times

Crusaders setting sights for Jerusalem

holy city of a different sort

whether nature and gods or kings and war

it is the sordid story of human history

everywhere from Chartres to Angkor

amid destruction and discord

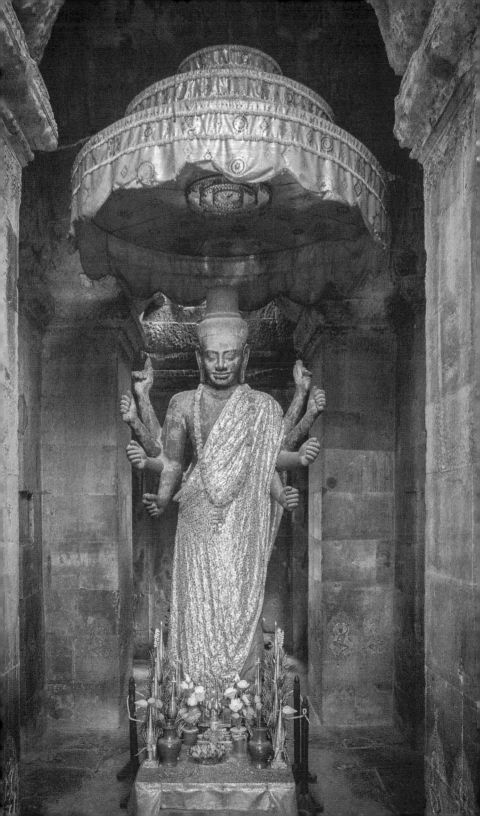

electric wire

Siem Reap

Kingdom of Cambodia

electric wires reach

stretching down streets

curled under teeth

and wrapped around

sound of motorbike

humming by

a bit of dust

floats through air

and catches your throat

as you sing, "ah, Cambodia"

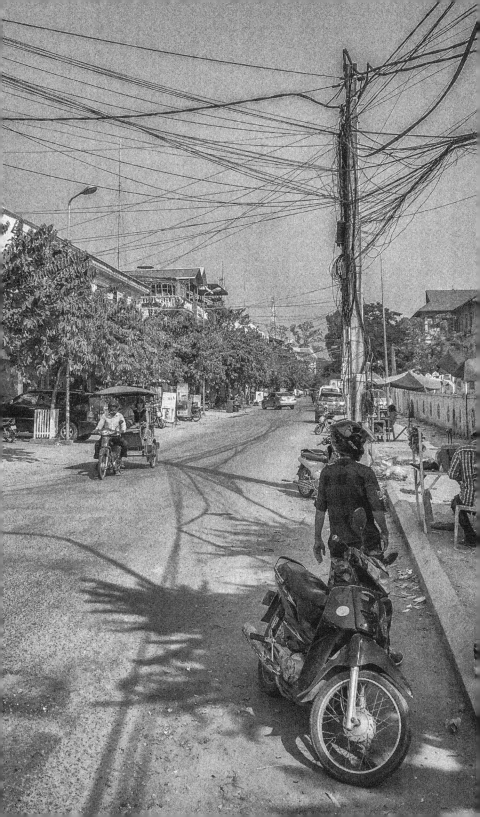

walk to the pagoda

slip off your shoes

—quietly—

shuffle your feet

and sit—meditate—

monks teach, watch

walk among you

robes of golden orange

umbrella fends off heat

sun shines bright

—the light—

in Siem Reap

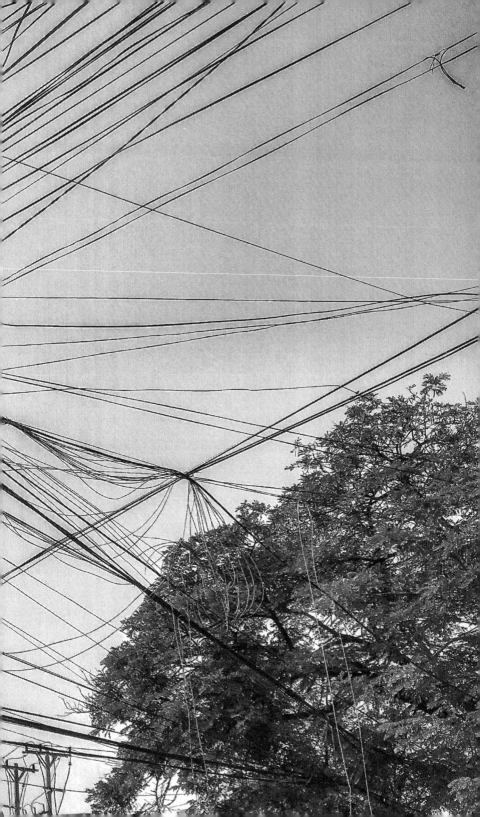

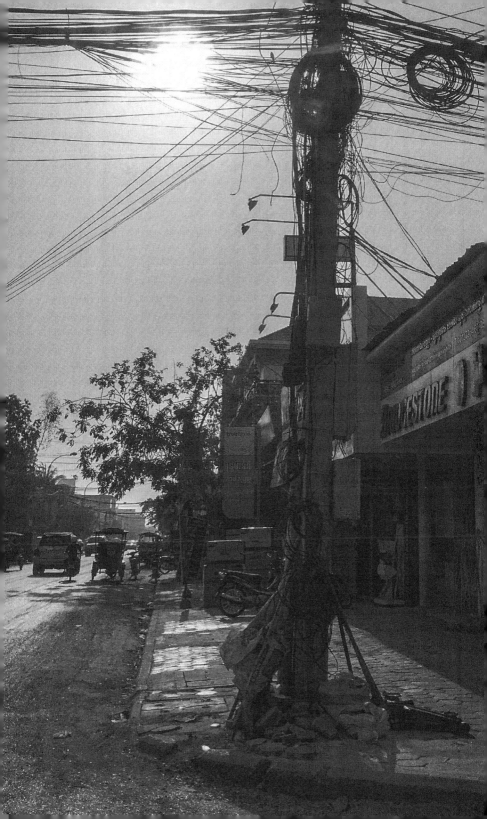

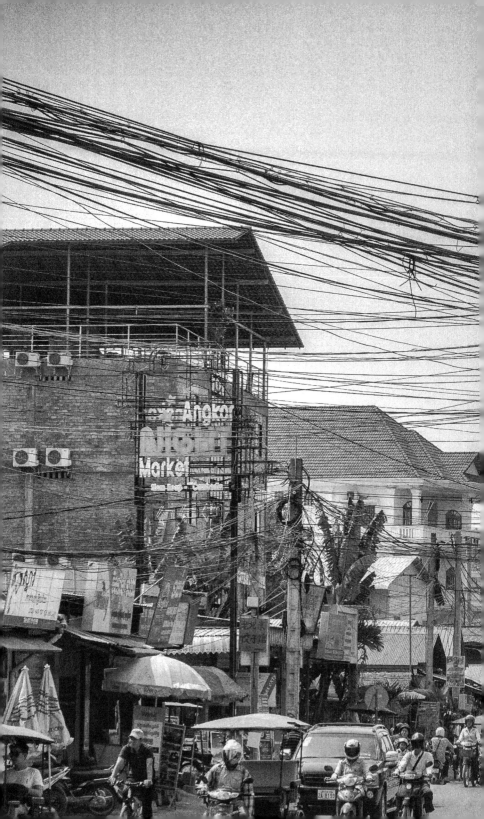

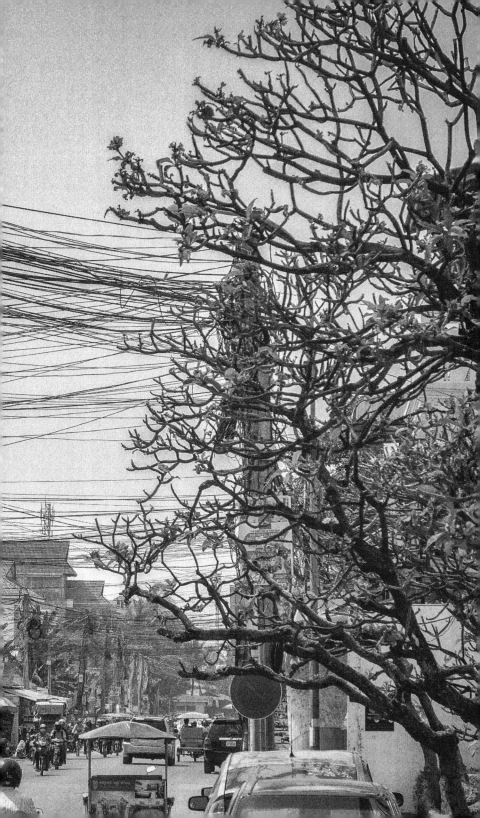

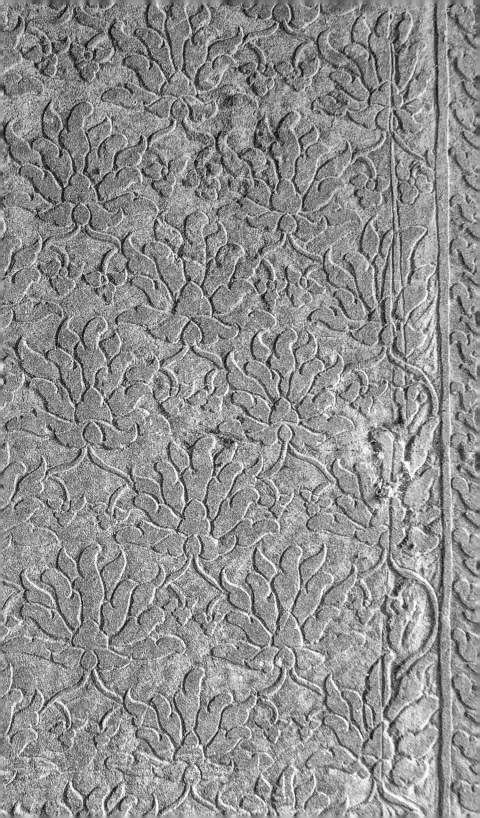

glossary

agnistambhasana — Yoga position known as "ankle to knee pose" in English.

Airavata — Mythological white elephant who is the mount of the Hindu god Indra.

Anavatapta — Lake at the center of the world according to ancient Buddhist cosmology. The name means "heat-free."

apsara — Celestial dancers who decorate many Khmer temples, especially Angkor Wat, where there are about 1,800 carvings of apsara.

asura — Malevolent Hindu deities/demons featured in the churning of the sea of milk story as depicted in bas relief at

Angkor Wat and the sculptures along the causeway upon entering Angkor Thom.

baray — An artificial reservoir constructed by the Khmer Empire.

Brahma — One of the three principle Hindu gods (along with Shiva and Vishnu), the creator.

Brahman — The highest Universal Principle in Hinduism, a metaphysical concept that binds together all humanity.

deoum rokar (ដើមរកា) — A tree with very hard, very sharp spikes covering its spine. The fruit is not edible. In Buddhist legends depicted in murals in pagodas in Cambodia, those who commit adultery are forced to climb this tree in hell, their naked flesh pierced by the thorns, as punishment. The tree is similar to, but not to be confused with, the kapok (ដើមគរ) tree, whose fruit is edible.

deva — (devata, plural) Benevolent Hindu deities/gods featured in the churning of the sea of milk story as depicted in bas relief at Angkor Wat and the sculptures along the causeway upon entering Angkor Thom.

ganas — Shiva's attendants that live on Mount Kailash.

Ganesha — One of the most popular of all Hindu deities. His half-elephant form makes him very distinctive.

Garuda — Mythical bird. The mount of Lord Vishnu. Sculptures with the body of man and head of Garuda appear at Banteay Srei as guardians along with similar

sculptures with heads of lion, monkey, and Yaksha.

gopura — Architectural term for the gateway of a temple enclosure.

Indra — Hindu god, leader of the devas, and king of Svargoloka. Indra's mount is Airavata.

Kailash — Lord Shiva resides at the summit of Mount Kailash in a state of perpetual meditation.

kondol (កណ្ដុលា) — Species of tree that bears beautiful flowers and large fruit. The sap of the tree can be used to dye clothing red. The tree can also be used as traditional medicine for snake bite. The bark of the tree can be cooked and drunk to help with an upset stomach.

Kulen (ភ្នំគូលេន) — Phnom Kulen, which means "mountain of lychees," is a mountain range near the Angkor Wat temple complex in Siem Reap Province, Cambodia.

lingam — A distinctive abstract and aniconic representation of Shiva, used for worship in temples and shrines and carved into the river beds.

Lokeśvara — Cambodian version of Avalokiteśvara, a bodhisattva embodying the compassion of all Buddhas. Different cultures interpret this bodhisattva as male or female. The female goddess Guanyin is the Chinese Buddhist equivalent.

Mahabharata — One of the two major Sanskrit epics. Part of the story is depicted in bas relief sculpture at Angkor Wat.

Mandara — Mountain that is used as a churning rod in the churning of the sea of milk story. Depicted in a major bas relief sculpture at Angkor Wat as well as numerous smaller sculptures in many different Khmer temples.

Meru — Mount Meru is a sacred mountain in Hindu, Jain, and Buddhist cosmology. Considered the center of the physical, metaphysical, and spiritual universes and the abode of the gods.

Naga — The serpents that form the balustrades at Angkor Wat and numerous other Khmer temples. Naga are important animals in Khmer mythology.

Nanda — One of the nagas associated with Anavatapta.

pagoda — The local temple and monastery complexes you find frequently around Siem Reap and around Cambodia. Note that the word is used differently in this context than the more familiar Chinese and Japanese multi-tiered structures also called pagoda.

Pey Tadi (ពយតាឌឬ ពើយតាឌ៏)— A steep cliff in the Dângrêk (ជួរភ្នំដងរែក) mountains upon which Preah Vihear temple is built. The cliff is named for a Cambodian soldier who, during the conflict with Thailand, jumped from the cliff in order to escape Thai soldiers.

plerr reak (ផ្លែរាក់) —You can eat the insides of these small pods and they taste similar to beans.

plerr pnek kong kepp (ផ្លែភ្នែកកងកែប) —This is sweet, a type of berry. The name refers to the fact that the berries look

like the eyes of a frog.

Prajnaparamita — Bodhisattva who is the personification of the concept of seeing the nature of reality.

Ramayana — One of the two major Sanskirit epics. Part of the story is depicted in bas relief sculpture at Angkor Wat. The Cambodian version of the Ramayana is called the Reamker.

Shiva — One of the three principle Hindu gods (along with Brahma and Vishnu), the destroyer/transformer.

sla thour bay sei (ស្លាធម៌បាយសី) — Decorations used in religious ceremonies, both in temples and at home. Traditionally made of banana leaves, today they are more commonly made of reflective gold and sometimes silver paper.

stupa — Structure with a distinctive and prominent mound or dome-like element which contains the remains of a deceased person. Often found within the grounds of Cambodian pagodas.

Svargaloka — One of the eight planes of existence in Hindu cosmology. It is a heaven where the righteous live before reincarnation.

tetrameles — Genus of trees growing in the ruins of Ta Prohm.

Thepphanom — A type of diety or angel who is a temple protector or guardian. Cambodians consider

all Thepphanom to be female. In Thailand, however, Thepphanom are boith male and female and typically presented in pairs as brother and sister.

trauy reang (ត្រួយរាំង) —A plant that is good for the stomach. It is often fried with corn oil.

tromoung (ទ្រមូង) — A plant used to make sour soup.

tuk tuk — A passenger-carrying trailer pulled by motorbike.

Upananda — One of the nagas associated with Anavatapta.

Vishnu — One of the three principle Hindu gods (along with Brahma and Shiva), the preserver.

war-knog (វល្លិក្នុង) — The leaf of this plant is used as traditional medicine to help with upset stomach. It is also used as flavoring for a stew.

yaksha — A class of nature-spirit. Sculptures with the body of man and head of yaksha appear at Banteay Srei as guardians along with similar sculptures with heads of garuda, lion, and monkey.

about the photos

The photographs in this book were taken in 2016 in Siem Reap, Cambodia and at the following temples and sites (in the order they appear in the book):

Angkor Wat, Baksei Chamkrong, Angkor Thom, Bayon, Ta Prohm, East Mebon, Jayatataka Baray, Neak Pean, Banteay Srei, Kbal Spean, Phnom Kulen, Preah Vihear, The War Remnant Museum, Koh Ker, Beng Mealea, Ta Som, Preah Khan

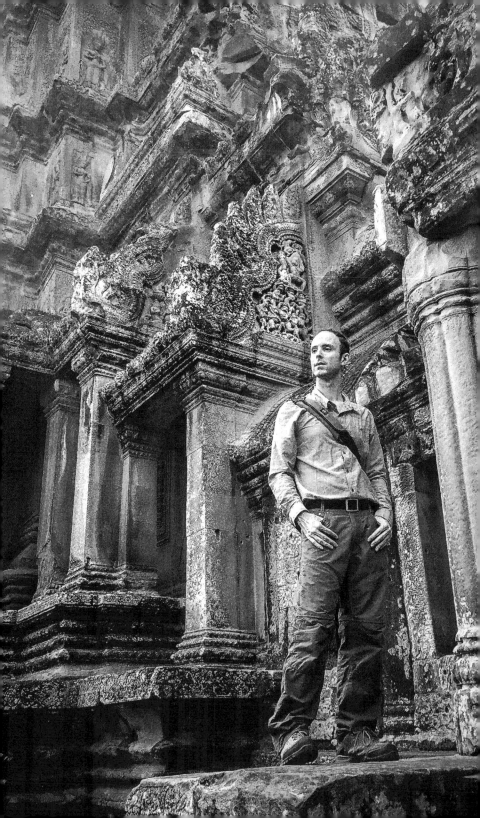

about the artist

luke kurtis is a Georgia-born interdisciplinary artist. *Angkor Wat* is his latest book in an ongoing series that combines photography, writing, and design, following *INTERSECTION* and *The Language of History*. He lives and works in New York City's Greenwich Village.

further reading

Ancient Angkor by Michael Freeman & Claude Jacques

Angkor Wat by Allen Ginsberg

Art of India and Southeast Asia by Hugo Munsterberg

Buddhist Painting in Cambodia by Vittorio Roveda & Sothon
 Yem

Cambodian Dance: Celebration of the Gods by Denise
 Heywood

The Civilization of Angkor by Madeleine Giteau

Elegy: Reflections On Angkor by John McDermott

Khmer Costumes and Ornaments by Sappho Marchal

Of Gods, Kings, & Men by Albert Le Bonheru

Temple in the Clouds: Faith and Conflict at Preah Vihear by
 John Burgess

other titles published by bd-studios.com

Glorious by Michael Harren

Puertas Españolas by Josemaria Mejorada and May Gañán

Kissing Hedwig by luke kurtis

marie was an artist by luke kurtis

Visions of the Beyond by Stefanie Masciandaro

Tentative Armor by Michael Harren

The Language of History by luke kurtis

INTERSECTION by luke kurtis

Retrospective by Michael Tice

Jordan's Journey by Jordan M. Scoggins